IMAGES
of America

LICKING COUNTY

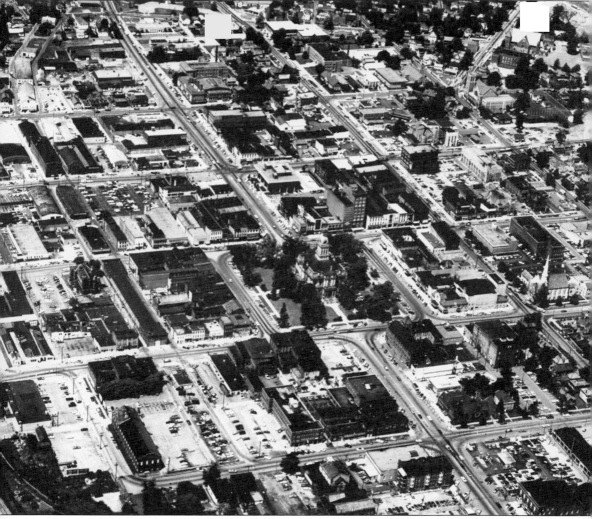

NEWARK, THE COUNTY SEAT. Newark was named as the county seat in 1808 and incorporated in 1933. In this 1970s aerial view, the streetscape was much different than today. The Auditorium Theater and the facade of the old Elks building were still standing, and the current public library, the Works, and Wendy's are not seen. (Courtesy of Tim Bubb.)

On the cover: **DOWNTOWN NEWARK.** In the 1940s, before the days of shopping malls, big-box stores, fast-food restaurants, and center street parking, downtown Newark was a lively, thriving center of activity in Licking County. The north side of the square shows the hubbub of shoppers visiting Kings, H. L. Arts, Nobil's Shoes, the Natoma, and other retail shops. (Courtesy of Chance Brockway.)

IMAGES
of America

LICKING COUNTY

Connie L. Rutter and Sondra Brockway Gartner

ARCADIA
PUBLISHING

Copyright © 2007 by Connie L. Rutter and Sondra Brockway Gartner
ISBN 978-0-7385-5154-8

Published by Arcadia Publishing
Charleston SC, Chicago IL, Portsmouth NH, San Francisco CA

Printed in the United States of America

Library of Congress Catalog Card Number: 2007930300

For all general information contact Arcadia Publishing at:
Telephone 843-853-2070
Fax 843-853-0044
E-mail sales@arcadiapublishing.com
For customer service and orders:
Toll-Free 1-888-313-2665

Visit us on the Internet at www.arcadiapublishing.com

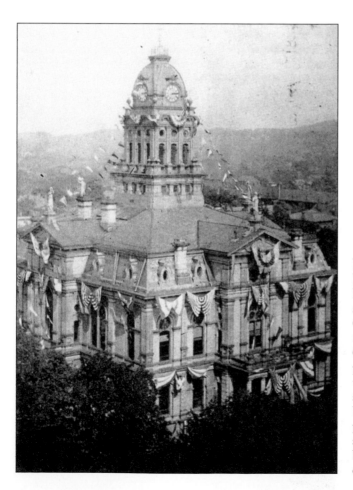

LICKING COUNTY COURT HOUSE. After the Civil War, honorably discharged Union army veterans organized the Grand Army of the Republic (GAR) in the late 1860s. The GAR was very powerful and prominent in both politics and veteran affairs, even lending a hand to elect some of the U.S. presidents. This 1909 photograph, reproduced from a glass negative, shows the beautiful "crown jewel" decked out in all its finest glory.

CONTENTS

ACKNOWLEDGMENTS

This book is affectionately dedicated to the loving memory of Chance Brockway, for without his great talent for photography, his endless love of history, and his vast collections of photographs, it would never have been possible to complete. He was very proud that we wanted to write this book for the Licking County bicentennial.

We would like to give a very special thank-you to all of those who submitted photographs of their townships and to Martha Sturgill from the Alexandria Museum, the volunteers from the Licking County Genealogical Society, Phyllis Riley and Wanda Higgins of the Utica Historical Society, Martha Tykodi of the West Licking Historical Society, Tim Bubb, Nola Rogers, David Phillips, Sue Williams, Natalie McWilliams, and Linda Hancock. Their vibrant energy and ensuing interest in supplying photographs for the book was beyond our expectations.

We would also like to acknowledge and give thanks to other "keepers of the past": C. W. "Bud" Abbott, Donna Braig, William E. Davis, Tom Huff, Aaron J. Keirns, Minnie Hite Moody, Dave Morrow, Bill Queen, John Skinner, Janice Wilkin, and others that strive today to keep history alive. Their collections of photographs, books, articles written, and passion for history have provided the people of Licking County an image of life long ago. May their works live forever!

And lastly, we would like to dedicate this book to our children and grandchildren. Our hope is, as they grow older, they learn to appreciate their legacy and endeavor to pass on to their own children and to their children's children the stories of their heritage.

INTRODUCTION

Licking County is located at the geographic center of Ohio, with its eastern part being hilly and rough and the western portion flattening out as the beginning of the midwestern plains. The history of the county really began over 2,000 years ago when an ancient people known as the Hopewell occupied the area. While they disappeared for no apparent reason, the large earthen mounds left behind give modern man clues to their type of culture. Licking County is home to countless numbers of these mounds, with the Great Circle Earthworks being one of the largest. Next to inhabit the area were the American Indians, likely the Wyandot, Shawnee, and Delaware. Prior to 1800, small villages were located below the junction of the north and south forks of the river running through the county that the American Indian tribes called the Lick-Licking. The name is supposed to have come from the salt licks that lay upon or near the banks that brought deer and buffalo and later domestic animals. The north fork of the river was called Pataskala.

In 1751, Christopher Gist, exploring in the interest of the Ohio Company of Virginia whose members listed some prominent Virginia gentlemen and two brothers of Gen. George Washington, crossed the Licking River at or near the mouth of Bowling Green Run, about four miles east of Newark. Around 1787, John H. Phillips, and his two younger brothers, and Thomas and Eramus, sons of Thomas Phillips, a Welshman of large fortune, decided to immigrate to America. John H. was the reputed author of some seditious or treasonable literature and left the country to avoid arrest and punishment. Along with the help of the Phillipses, many of their Welsh neighbors purchased 2,000 acres of land situated in what is now the northeast quarter of Granville Township.

Early in 1802, William Schenck, G. W. Bernet, and John Cummins came from a settlement in Jersey to inspect a section of military land they had purchased. After surveying the area and platting a town at the forks of the Licking River, they decided to call it "New Ark" after Schenck's native town in New Jersey. The plat was recorded in Lancaster, the county seat of Fairfield County, which included at that time New Ark. However, shortly after the original plat was drawn, an alteration was made and the town's name was spelled as one word. In 1808, Licking County was established with Newark as its county seat. The village continued to grow in population and was incorporated under the laws of the State of Ohio in 1833.

By the 1820s, the pioneers were living life a little easier. Their farms were partially cleared—many were living in hewn log houses, frame, and even brick homes. Most had barns and innumerable outhouses; they generally had cattle, horses, sheep, hogs, and poultry.

The construction of the Ohio Canal began in 1825 and finished in 1833. The canal brought a new era to the county. Newark grew to become a beehive of activity with farmers bringing produce and meat to market for shipping to other parts of Ohio and points east. But the railroads came, and the canal gradually began to lose its value. The canal system peaked around 1851, and by the 1890s, the boats were no longer passing through. In 1908, the great Ohio Canal was filled in.

In 1832, the Licking County Agricultural Society began holding fairs at the Great Circle Mound located at the "Old Fort" in what is now known as Moundbuilders Park. In the late 1800s, the fairgrounds thrived when the interurban was introduced. This provided a direct line from downtown to the fairgrounds. During that time the fairgrounds were known as Idlewilde Park.

October 1861 brought a new use for the Old Fort when it served as the rendezvous for the 76th Regiment of Ohio Volunteers. It was renamed Camp Sherman, and local son and West Point graduate Col. Charles R. Woods was put in command. On February 9, 1862, the new enlistees from the camp found themselves on the battlefront.

After the Civil War in 1898, J. F. Lingafelter, a banker, brought a summertime entertainment resort to the fairgrounds, but its short life ended after the Buckeye Lake Park was built in 1910. Known as the "Playground of Ohio" with its hotels, amusement rides, swimming pool, skating rink, concession booths, and games, over time the park brought in hundreds of musicians and celebrities and thousands of fans. But alas, the park closed in 1972.

For the past 200 years, many people have had a connection to Licking County. These people are legendary, and their names continue to keep the history of our county alive. Harry C. Beasley (1883–1931) was a Newark police officer that was gunned down by safe robbers on June 30, 1931. He was awarded the Congressional Medal of Honor, the nation's highest military honor, in 1914 while serving with the U.S. Navy at Vera Cruz, Mexico, where Pres. Woodrow Wilson had ordered the interception of a German ship carrying arms for Gen. Victoriano Hueta. His murder remains unsolved today.

John Chapman (1774–1845?) was known as "Johnny Appleseed." The folklore hero scattered the Licking County countryside with seeds of apples and wild herbs. Many of his original trees still stand in the county today. Cora Bell Clark (1867–1939) began working at the First National Bank in Utica at the age of 15 years. She became the first woman cashier of a national bank in the United States and went on to become the first woman to hold the title of bank president. Her bank remained open during the Great Depression.

Maj. Gen. John Lincoln Clem (1851–1937) ran away from his Newark home at the age of 10 and joined the Union army. On April 6, 1862, the boy of 11 marched into battle at Pittsburgh Landing, Tennessee. He died in San Antonio, Texas, at age 86. Beman Gates Dawes (1870–1953) was the founder of the Pure Oil Company. With his wife, Bertie, he established the Dawes Arboretum in 1929.

Woody English (1907–1997) began his professional career in baseball in 1925, playing shortstop for the Toledo Mud Hens. He continued his renowned profession with the Chicago Cubs before being traded to Brooklyn. He later retired in 1938.

Edward Hamlin Everett (1851–1929) was known as the "Bottle King." He began his realm in 1880, when he purchased the Newark Star Glass Works. He later founded the Ohio Bottle Company. His other businesses included gas exploration and fruit orchards. The millionaire died in Boston from complications following a surgery for prostate cancer. Howard LeFevre (1907–) is the founder of the B&L Trucking Company, a philanthropist, benefactor, and Ohio State University fan extraordinaire.

Amzi Godden (1815–1855) was a noted artist who lived in Newark after 1820. His genre was portraits. He died of tuberculosis or "white plague" and is buried in Cedar Hill Cemetery, Newark. William Welles Hollister (born in 1818) left Hanover in 1854 with the first large transcontinental sheep drive, bringing 6,000 merino sheep from Licking County to California during the gold rush. He arrived with only about 1,000. Hollister founded

Hollister, California, and made his fortune in wool and profits from his more than 20,000 fruit trees.

Elias Hughes (born sometime before 1755 and died in 1844) was considered to be the first permanent white settler of Licking County in 1798. He was a hunter in a surveying party when he first set eyes on the area. Later in life he was known as an American Indian scout and is thought to have been over 90 when he died and was buried with military honors in the Utica Cemetery.

Born in Chatam, Leonidas H. Inscho (1840–1907) also received the Congressional Medal of Honor. His citation dated January 31, 1894, reads, "Alone and unaided and with his left hand disabled, captured a Confederate captain and 4 men. Corporal, Company E, 12th Ohio Infantry, at South Mountain, MD, 14 Sept 1862."

Mary Sherwood Wright Jones (1892–1985) was a noted muralist and illustrator for children's books, including the renowned national publication of *Weekly Reader*. Thomas D. Jones (1812–1881) was a stone cutter who began his career cutting stone blocks on the Ohio Canal before turning to the fine arts of sculpture. He was the only sculptor that Abraham Lincoln would sit for, and one bust of Lincoln now adorns the statehouse rotunda in Columbus.

Geraldine "Jerrie" Fredritz Mock (1925–) is a world-renowned aviatrix. Breaking many world aviation records, she received the Federal Aviation Agency's highest award as the first woman to fly solo around the world. Lee Ann Parsley (1969–) was a 2002 Olympic silver medal winner in Salt Lake City, Utah, in the winter sport of skeleton.

Joseph Rider (1817–1901) was a Newark gunsmith who held over 100 patents for his gun designs. The Remington Company sold thousands of Remington Rider breech-loading muskets, and the patent royalties from his other gun designs made him one of Newark's wealthiest citizens. It was rumored that he received as much as $400 per day from these royalties.

Bishop Sylvester Horton Rosecrans (1827–1878) was born in Homer. He converted to Catholicism in 1845, was ordained as a bishop in 1862, and became the first bishop of Columbus in March 1868. His brother was Maj. Gen. William Starke Rosecrans.

Edward James Roye (1815–1872) was a Newark black man elected as the fifth president of the Republic of Liberia in Africa in 1870. Alexander Samuelson (1862–1934) was born in Sweden, lived and worked in Newark, and has been credited with inventing the original "hobble skirt" Coca-Cola bottle in 1915.

John Sparks (1758–1846) was an original member and scout for the Zebulon Pike Expedition across the continent. Pres. Thomas Jefferson sanctioned this noted expedition in 1804. Sparks is buried in Hollar Cemetery.

John H. Swisher and his brother Harry purchased a cigar business from their father, David, in Newark in 1888. The two brothers took what had been a one-room operation capable of making a few hundred cigars and turned it into a very successful business. By 1895, the cigar company had grown to three factories that employed more than 1,000 workers, rolling out as many as 300,000 cigars each day.

La Marcus Adna Thompson (1848–1919) was born in Jersey. Sometimes known as the "Father of Gravity," Thompson is best known for his early work developing roller coasters. His Switchback Railway opened at Coney Island, New York, in 1884 and was the first gravity-powered roller coaster built in the United States.

Clarence Hudson White (1871–1925) was a prominent amateur photographer who lived in Newark. He was a self-taught photographer who took his photography to an art form. White organized the Newark Camera Club, and by the early 1900s the club had achieved world-renowned status. He was the founder of the Clarence H. White School of Photography in New York.

Victoria Claflin Woodhull (1838–1927) was a feminist pioneer from Homer. She rose from poverty to become the first woman to sit on Wall Street at the New York Stock Exchange as

a broker, the first woman to testify before Congress, and the first woman to run for president of the United States.

Brev. Maj. Gen. William Burnham Woods (1824–1887) was nominated as a U.S. circuit judge by President Grant in 1869. Ten years later President Hayes nominated him as an associate justice of the U.S. Supreme Court.

One

HARTFORD AND BENNINGTON TOWNSHIPS

Coming to the county in April 1812, Daniel Poppleton was the first settler in Hartford Township. Once a part of Bennington Township and before that, Monroe Township, Hartford came into its own in 1819. When first settled, the township was divided into two halves. The western half became known as "school land" because the profit from the sale of this U.S. government land was to be used for establishing or supporting schools. Early communities included School Land (also known as Freeman), Granby then Croton (now known as Hartford), and Willison Corners.

The first settling of Bennington Township was in 1809, when Henry Iles, a Virginian, settled there. Bennington Township was organized in 1815. One prominent figure from the township was a young gentleman clerk named "Billy," later known as Maj. Gen. William Stark Rosecrans, the hero of Stone River and commander of the Union forces at the Battle of Chickamauga. Some early communities included Appleton, Bennington, Cooks Settlement, Decrow Corners, and Lock.

This is about the Hartford Fair where we go in August!

Croton hasn't really changed much

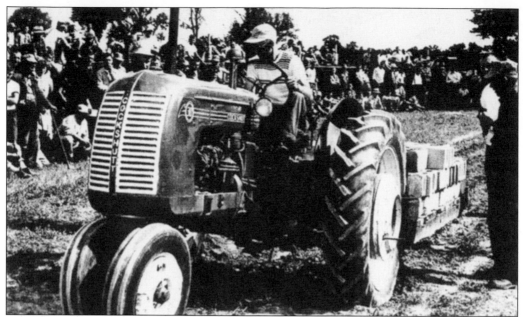

TRACTOR PULL. The tractor pull is one of the main attractions at the Hartford Independent Agricultural Society, better known as the Hartford Fair. Located in the northwest corner of Licking County, the fair is unique from other Ohio fairs because it incorporates directors from Licking County and two neighboring counties, Delaware and Knox. In 2008, the Hartford Fair will celebrate its 150th year in existence. (Courtesy of Hartford Fair Board.)

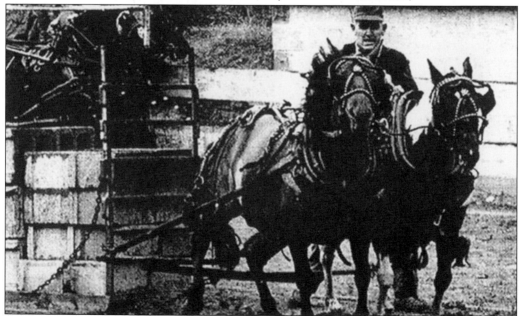

HORSE PULL. In 1858, when the fair was called the Hartford Fair Society, people came to Croton on the train and had to be transported to the grounds by horse and buggy. After automobiles became popular the hitching posts were removed and replaced with parking lots. With the installation of electricity, the night fair came about, and today the grounds have 44 buildings sitting on 145 acres. (Courtesy of Hartford Fair Board.)

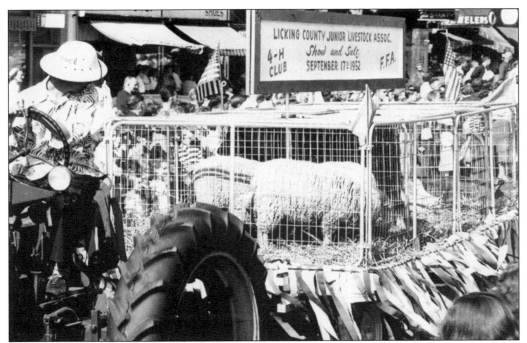

PARADE FLOAT FOR LICKING COUNTY JUNIOR LIVESTOCK ASSOCIATION. The Licking County Junior Fair was added to the fair program in 1938. Since then the majority of the growth of the fair has been with youth organizations and centered on their activities. The Hartford Fair has one of the largest junior fair programs in the state. (Courtesy of Tim Bubb.)

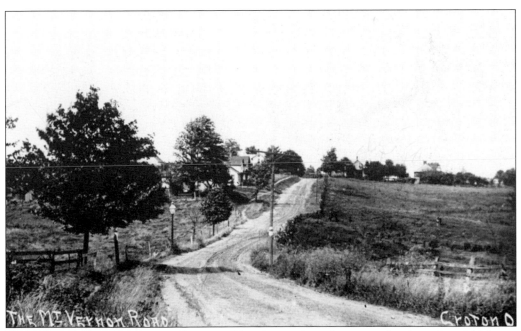

THE MOUNT VERNON ROAD, CROTON. Travel must have been very hard on the old Mount Vernon Road leading into Croton, now known as Hartford. It is not known what is perched on the post on the left side of the road at the curve. Could it be a streetlight or a birdhouse?

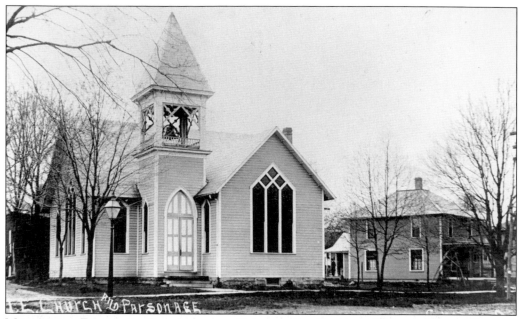

METHODIST EPISCOPAL CHURCH AND PARSONAGE, CROTON. This appears to be new construction of the Methodist Episcopal church and parsonage in Croton. The date of the photograph is not known, but if it was known whether the light post held a gas or an electric light it might help give a clue as to when the picture on the postcard was taken.

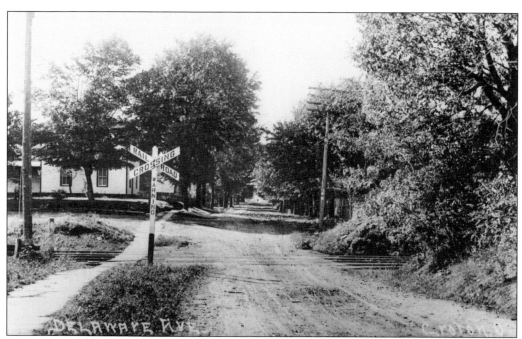

DELAWARE AVENUE, CROTON. Only one lonely railroad crossing sign gives warning to the traffic on the tree-lined dirt road named Delaware Avenue in Croton.

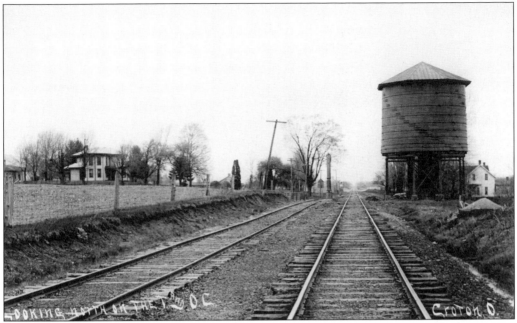

LOOKING NORTH ON THE TOLEDO AND OHIO CENTRAL RAILROAD, CROTON. The large water tower located on the right was used to provide water for the trains. Before the days of diesel engines the old coal engines needed water to help make the steam that made the trains run. The water was held in a tank located behind the coal tender. Today the old water towers have all but disappeared.

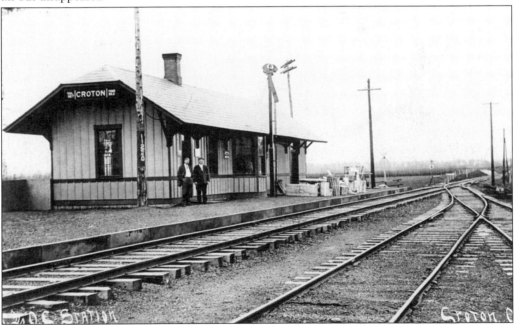

TOLEDO AND OHIO CENTRAL RAILROAD STATION, CROTON. The Toledo and Ohio Central Railroad was primarily a coal-hauling line from the mines of the Ohio River Valley to northwest Ohio, and the first line to offer passenger service to local communities, including Granville. The old depot station in Granville still exists and is now a private business.

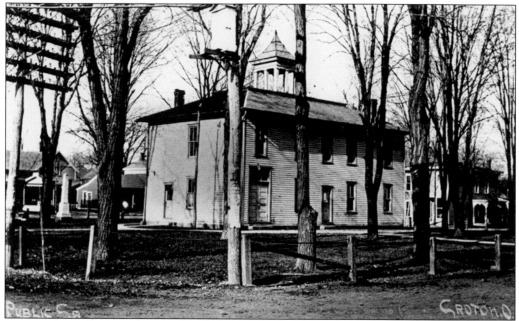

PUBLIC SCHOOL, CROTON. Before the days of large populations of students and school consolidations, each village and township had its own schoolhouse. Most had only one room and just one teacher teaching all the students. This one, located in Croton, was a larger building with two floors.

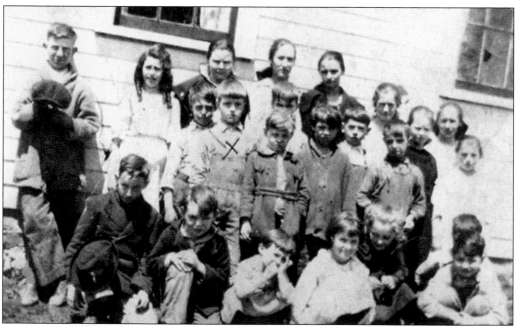

BENNINGTON TOWNSHIP, APPLETON SCHOOL. Since there was no railroad, telegraph, canal, or river within Bennington Township's boundaries, it was essentially made up of farmers. It was common for all students to be educated in one room and very uncommon for the student to complete 12 years of education. When they reached puberty age, many children would quit school to help out at home or to run the farms.

Two

BURLINGTON AND WASHINGTON TOWNSHIPS

James Dunlap was one of Burlington Township's first settlers in 1806. A few hardy souls stayed until 1817, when Burlington Township became organized. In 1825, the great Burlington storm, a violent, deadly tornado, caused the instant death of the 14-year-old son of Col. Wait Wright when he was thrown across the room of their log home. Two other young men were also killed by the storm. Other happenings of the storm included an ox left unhurt after being picked up and thrown 80 rods away, a crockery crate housing several fowl carried several miles and set down without injury, and Sarah Robb carried about 40 rods away and left safe, but badly bruised. Early communities included Barrick Corners, Burlington (now Homer), Cranetown, Jenkins Corners, Patterson Corners, Pattons Corners, Puckerville (also known as Lafayette), Six Corners, Stinger, and Snyder.

Around 1808, Joseph Conrad became one of the first to settle in Washington Township. The township became organized about 1812. One early community was named Squawtown, a settlement two miles east of Utica. Legend tells the tragic tale of a card game in which a Mr. McLean lost. The stakes were extremely high, for the loser had to shoot an American Indian squaw that was camped nearby. McLean was later found guilty and sentenced to two years in the state prison. Smoketown and Wilmington were other early settlements. Wilmington was renamed Utica when the post office was established, for there was already another Wilmington in another county of the state.

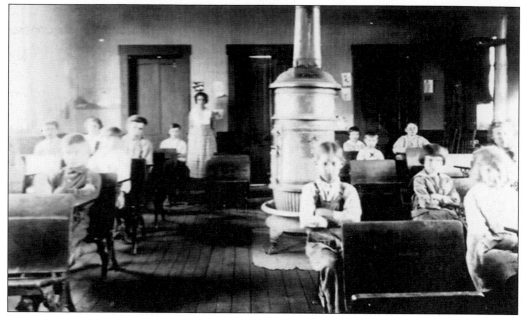

BURLINGTON SCHOOL. Before the days of central cooling and heating systems, it was common for the one-room school to be heated by a large coal or wood stove. This schoolroom in the Burlington Township School building had one such stove located in the center of the room. Even then the students had the same expressions on their faces as they do now wondering, "Was that the bell?" (Courtesy of Nola Rogers.)

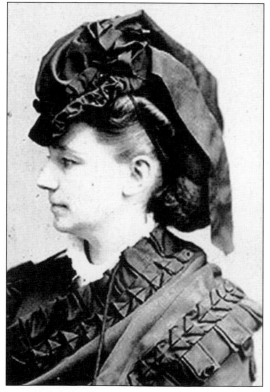

VICTORIA CLAFLIN WOODHULL. Victoria Claflin Woodhull grew up poor in Homer. Her life reads like a dime-store novel that included spiritualism, fortune reading, lecturing, newspaper publishing, and adultery. She was also a mother of two, involved in finances as a stockbroker, spent time in jail, dabbled in politics, and the list goes on. Her name appeared on the U.S. presidential ballot in 1880, 1884, 1888, and 1892. She eventually married a wealthy banker and died in England.

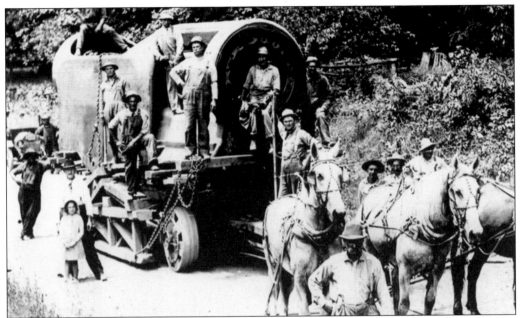

TEAMSTERS. In 1903, teamsters posed for the camera at the Baltimore and Ohio Railroad (B&O) depot in Utica with the large compressor casting bound for the Ohio Fuel compressor station at Homer. The long haul took four days to complete. The horse-drawn equipment was moved from the station, down Main Street, through the covered bridge across the creek, and out to the Homer Road. (Courtesy of Utica Historical Society.)

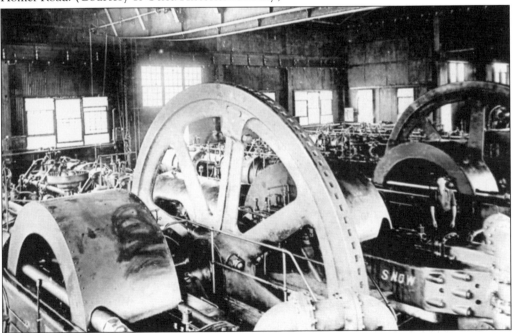

COMPRESSOR IN PLACE AT THE HOMER PUMPING STATION. A total of eight loads of complete engines were moved in four years. Some loads could have weighed 36 tons and taken 48 to 64 horses to move. Here the engine is installed at the pumping station and is up and running. (Courtesy of Utica Historical Society.)

J. A. Cree Machine Shop, South Main Street Utica, 1909. Around 1900, C. A. Berit owned a carriage shop in the building where the Cree Machine Shop, shown here, was established in August 1903. J. Albert Cree opened the J. A. Cree Machine Shop for oil and gas well equipment. The building was razed about 2005. (Courtesy of Utica Historical Society.)

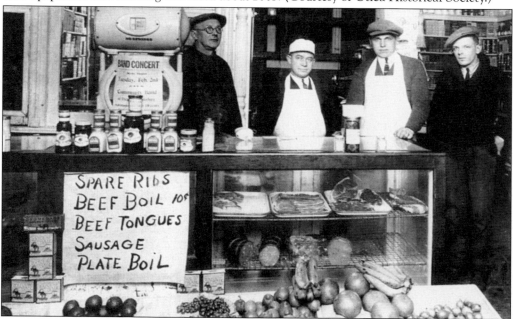

Buxton Grocery Store, Utica. In the 1930s, George Buxton operated his market in the back room of the Savings Bank Building. His grocery was well known for his fresh meats and Mrs. Ernest Tulloss's fresh country butter. Although Buxton is not identified in this photograph, it is known that the gentleman on the far right is Wesley Lupher, who owned the Jug Run Grocery Store in Fallsbury. (Courtesy of Barbara Lupher.)

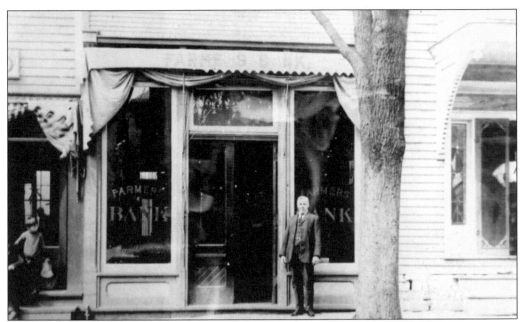

FARMERS BANK, UTICA. In 1888, Fred S. Sperry and Reid Dunlap became co-owners of the Farmers Bank, but in 1895, Sperry bought the bank from Dunlap. It operated as a bank until 1931, when the doors had to close. Two other banks in Utica obtained all the assets of the debunked bank and paid the depositors in full. One of those banks was the First National Bank of Utica. (Courtesy of Utica Historical Society.)

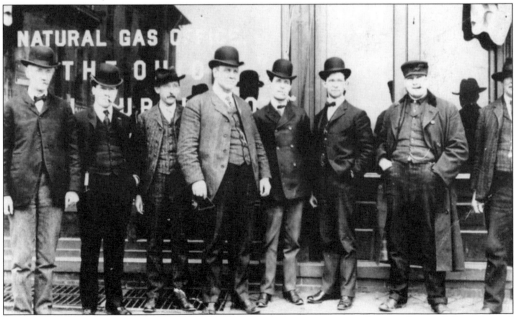

NATURAL GAS OFFICE, UTICA. These dapper gentlemen are standing in front of the Natural Gas Office about 1900. At that time the fields around Utica were rich in natural gas and farmers around Utica were even richer. Many farmers leased their land to gas companies for as much as $5 per acre, some receiving nearly $100,000 each year from these leases. (Courtesy of Utica Historical Society.)

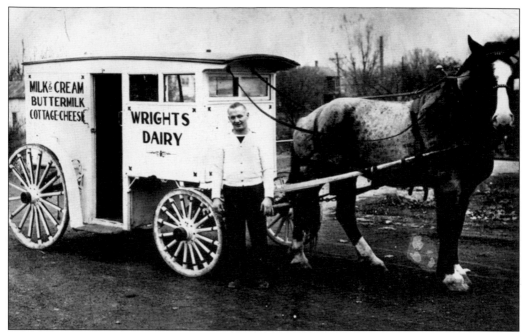

Wright's Dairy, Utica. Wright's Dairy Factory was located on South Washington Street. Around 1925, Eddie Wright began delivering door-to-door fresh milk in glass bottles, cream, buttermilk, and cottage cheese to his customers with his horse-drawn milk wagon. The business was sold in 1949 to Herbert and Norman Fleming. (Courtesy of Utica Historical Society.)

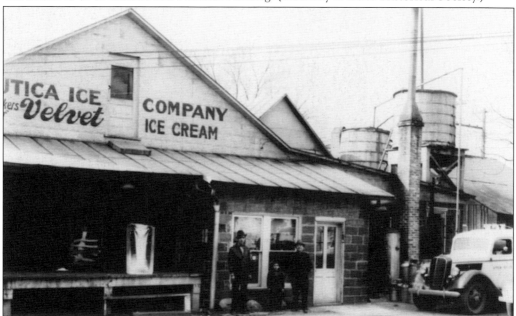

Utica Ice and Ice Cream Company, Utica. In 1915, customers could buy clean fresh ice completely free from the impurities found in creek water ice. And the best part—they could have ice delivered on demand, day or night. The Utica Ice and Ice Cream Company was the predecessor of Velvet Ice Cream. Pictured here, from left to right, are Charles Dager, unidentified, and Abe Ritchey. (Courtesy of Utica Historical Society.)

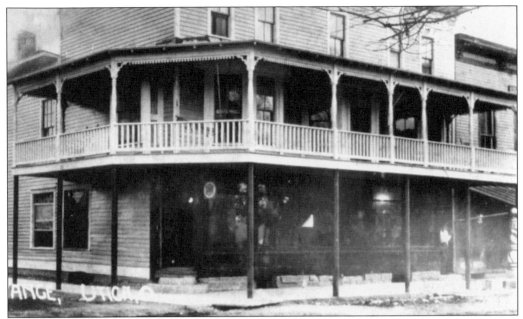

HOTEL VANCE. Considered one of the area's finest in its heyday, the Hotel Vance, built in 1869 on Main Street in Utica, boasted 63 lighted, gas-heated rooms and electricity. The room rate was $2 per day on the American plan. Fire destroyed the hotel in 1909. No water was available to douse the fire. The village did not have a community water system until 1910. (Courtesy of Utica Historical Society.)

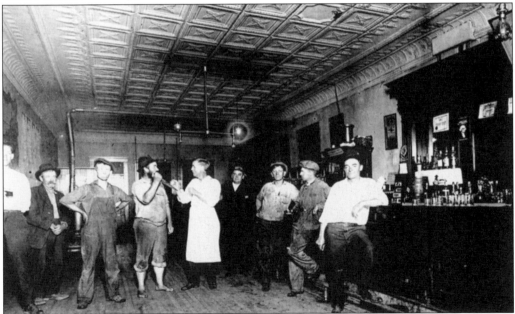

SMITH MENDENDALL SALOON, UTICA. In 1915, local glassworkers packed the Smith Mendendall Saloon. Pictured from left to right are Stanley Smoots Sr., John Taylor, Piggy Knoth, Dakota Joe Sutton, William Robertson, Rube Cuffman, Ken Knoth, unidentified, and Mac McNees. Proprietor William Robertson (the son of the founder of Utica) is in a little friendly fisticuffs position with Dakota Joe. (Courtesy of Utica Historical Society.)

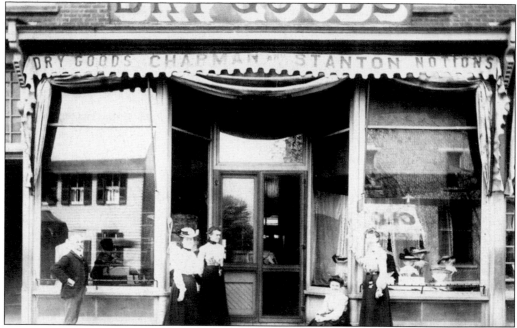

CHAPMAN AND STANTON DRY GOODS AND NOTIONS, UTICA. Three generations of Chapmans served their Utica customers well with the Chapman and Stanton Dry Goods and Notions. They were well respected in the business of selling dry goods, clothing, and notions. First was Salathiel, then Sidney, and finally Edward, whose *c.* 1900 store was located in the Wilson block. The three-storied Wilson block was destroyed in the fire of 1909. (Courtesy of Utica Historical Society.)

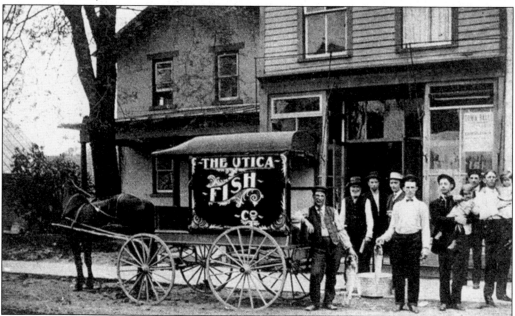

UTICA FISH COMPANY, UTICA. A common sight in Utica about 1908 was the Utica Fish Company's horse-drawn wagon. Here it is seen at the left side of the building where Watt's Restaurant is located today. (Courtesy of Utica Historical Society.)

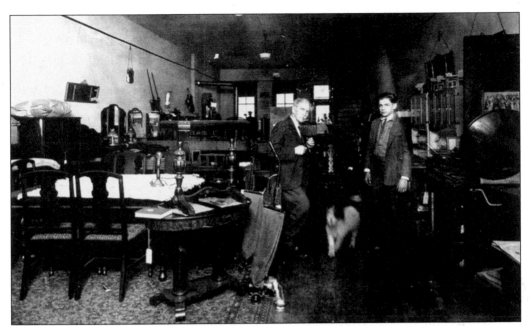

FURNITURE FACTORY, UTICA. In the late 1920s, George Bender moved from Columbus and started a furniture factory in a warehouse building that was left standing after the Utica Glass Company's main building burned. At one time he employed about 50 men to make small end tables, taborets (small drum-shaped tables), and piano benches. His furniture graced many homes, but the company ceased operation about 1930. (Courtesy of Utica Historical Society.)

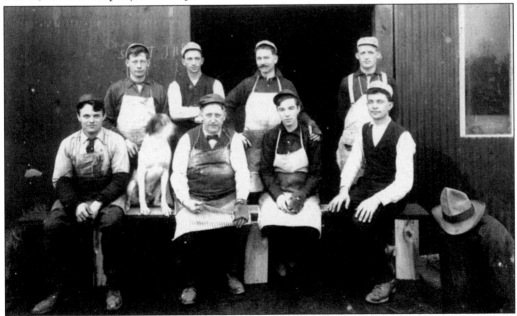

WORKERS AT THE GLASS FACTORY. Called the "Golden Age of Glass," Utica boasted five different glass factories: Utica Glass Company (1903–1929), the Central Window Glass Company (1905–1912), the Advance Glass Company (1906–1911), the Licking Window Glass Company (1906–1922), and the Corl-Erie Glass Company (1928–1929). (Courtesy of Utica Historical Society.)

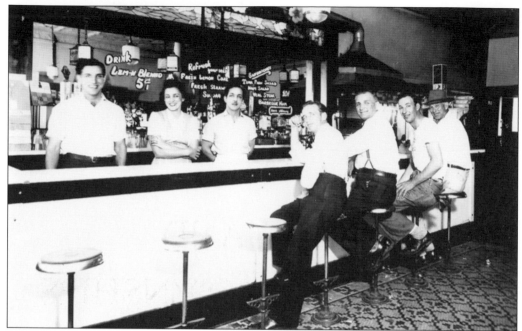

RITCHEY BROTHERS CONFECTIONARY, UTICA. One popular place for everyone to visit and get a great sandwich for a dime and a drink for a nickel was the Richey Brothers Confectionary. Pictured from left to right are Phil Ritchey, Josephine Ritchey, and Jim Ritchey. The names of the smiling customers are unknown. (Courtesy of Utica Historical Society.)

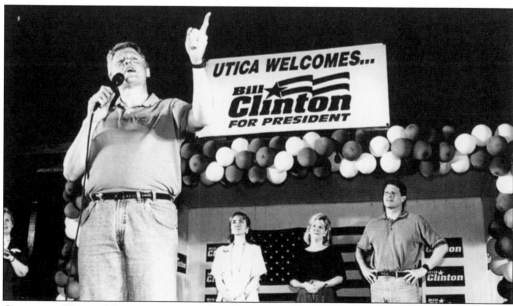

CAMPAIGN TRAIL. Utica is accustomed to seeing "royalty." In 1908, President Taft came to town, and in July 1992, Democratic presidential nominee Bill Clinton visited, accompanied by his wife, Hillary, vice president nominee Al Gore, and Gore's wife, Tipper. When Taft came to town he rode in on the train—Clinton's cavalcade consisted of eight busloads. Clinton was elected president of the United States and served two terms. (Courtesy of Utica Historical Society.)

Three

EDEN AND FALLSBURY TOWNSHIPS

With its many valleys, great numbers of fresh springs, lush vegetation, and the abundance of wild game, William Shannon, Jesse Oldaker, and Ebenezer Brown, the first setters in 1813, could easily have called the place the Garden of Eden. Eden Township was organized in 1822, from territory originally included in Mary Ann Township. Early settlements include Colville (also known as Long Run and Oberlin), Morris Hill, Purity, and Rain Rock.

Building his cabin in 1818, David Bright became the first settler of Fallsbury Township. It was organized in 1826, when the first election was held at the house of Samuel Varner. Early settlements include Egypt, Fallsburgh (also called Van Winkle and now Fallsburg), Frampton (also called Goshen), Gilberts Mills, Gregg Mill, Henpeck Corners, and Tilton's Crossroads.

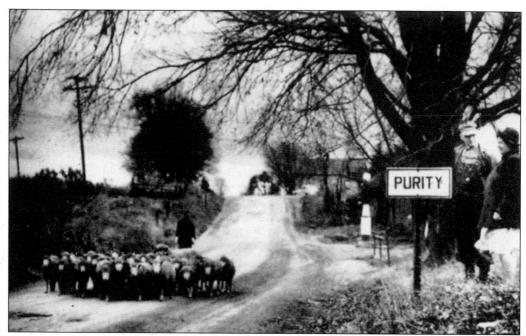

HERDING SHEEP THROUGH PURITY. Even before 1850, flocks of sheep were a common sight feeding on the lush green grasses of the county. This sheepherder drives his flock on the road leading from the small village of Purity. The photograph was probably taken in the late 1930s. (Courtesy of David Phillips.)

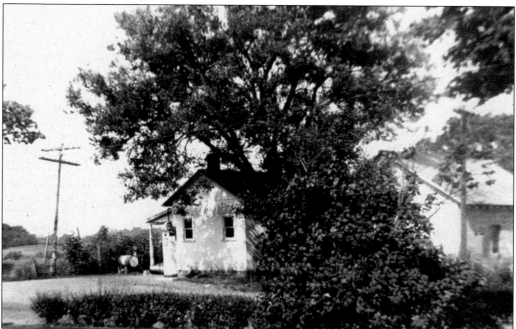

PURITY STORE. The post office of Purity was established in 1888, and when it closed in 1904, the mail was transferred to St. Louisville. Not much is known about the Purity Store other than the building was moved to this location. It is unknown if the post office was located within the store, but it was certainly not uncommon if it had been. (Courtesy of Don Glover.)

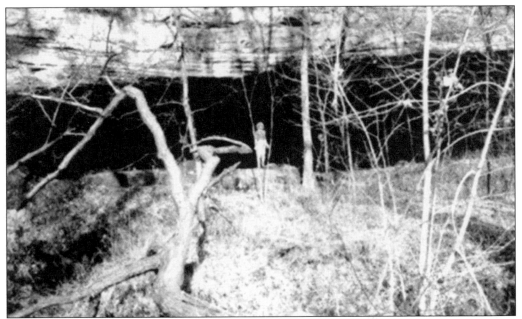

RAIN ROCK. This natural formation was once described as a "gloomy, cavernous-looking excavation, and a shelter where a hundred people or more might escape from a storm." In various places through the crevices of this rock roof, clear, sparkling springwater issues and keeps up an incessant dropping, year after year, upon the sand beneath, hence the name Rain Rock. (Courtesy of Nola Rogers.)

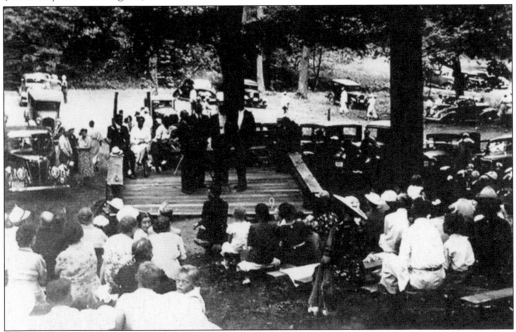

CAMP MEETINGS AT RAIN ROCK. A short distance from Rain Rock was a flat rock, 4 or 5 feet high, and 10 or 12 feet in diameter across the top, with a smooth surface, known as Pulpit Rock. Ever since this area was discovered, people have congregated for social interaction. This photograph shows one such camp meeting. (Courtesy of Twila Mizer Morningstar Bodle.)

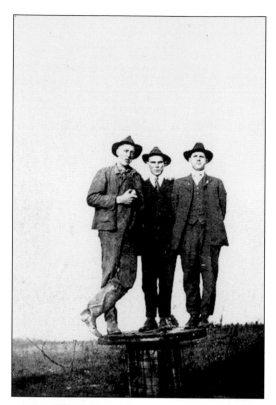

TALL MEN OF FALLSBURG. Kyle Varner, Henry Billman, and Elmus Moore are called the "tall men of Fallsburg." The three men posed on an empty cable spool for this photograph in the early 1900s. (Courtesy of Kenneth and Shirley Varner.)

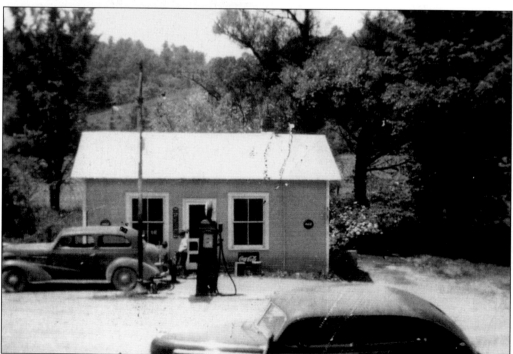

JUG RUN STORE. Long before the days when gasoline cost $3 or more a gallon, Wesley Lupher sold gas at his place, the Jug Run Store. (Courtesy of Barbara Gault Lupher.)

MOUNT PLEASANT CHRISTIAN CHURCH.
Located on Church Road in Fallsbury
Township is the Mount Pleasant Christian
Church. The congregation was organized
and founded in 1868 by the Reverend
William Webb. The church celebrates its
139th year in 2007. Membership today is
approximately 65, and the present pastor is
Karl Hoffman. (Courtesy of James and Judy
Moran Ashcraft.)

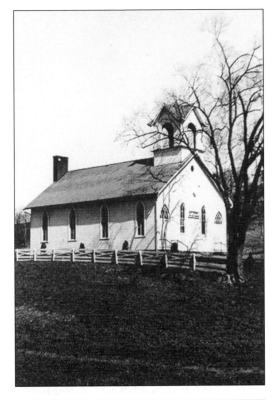

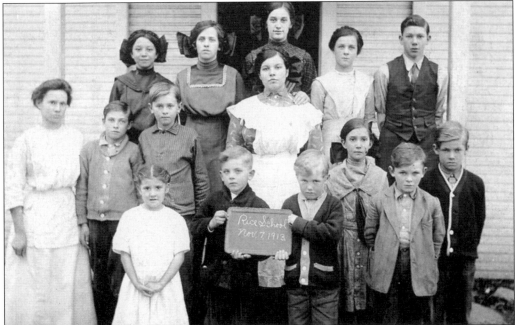

RICE SCHOOL. The Rice School was a one-room schoolhouse located on Route 586, about a
mile north of Fallsburg. The classes of 1913 consisted of 14 children of all ages. The building
is still standing today and is currently used as a Grange hall. (Courtesy of James and Judy
Moran Ashcraft.)

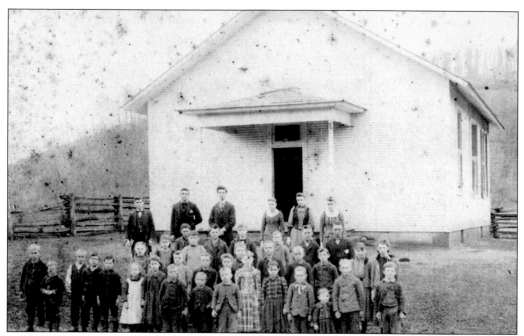

GOSHEN SCHOOL. This little one-room schoolhouse is still standing on Frampton Road in an area once known as Little Egypt in the Valley of Wakatomika. The Wakatomika could have been named by possibly the Shawnee Indians that camped in that region before the township was settled in 1818. (Courtesy of Twila Mizer Morningstar Bodle.)

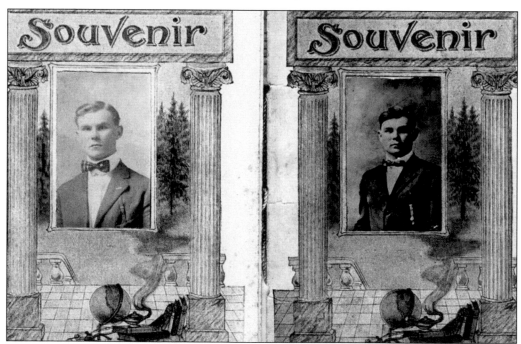

TWIN TEACHERS AT GOSHEN SCHOOL. At one time, school programs were sometimes used as calling cards or as souvenirs. Goshen School was fortunate to have two distinguished teachers in 1914 and 1915—twin brothers. (Courtesy of Kenneth and Shirley Varner.)

OTTO LAKE. When Fredrick Pauli, a Russian, went to Switzerland to learn how to make cheese, his daughter Anna was born. In Switzerland, Anna met and married Otto Jacob Stockli. They migrated to America and opened a cheese factory in Warsaw. They had a son named Calvin Otto Stockli, after Pres. Calvin Coolidge. This lake is on their homestead. (Courtesy of Kenneth and Shirley Varner.)

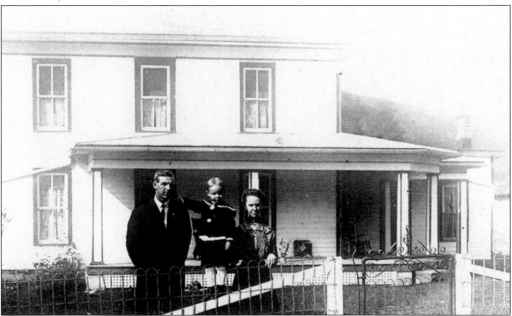

FRAMPTON POST OFFICE. The Frampton Post Office was established on April 4, 1884. Upon its closing on March 31, 1904, the mail service was transferred to Fallsburg. In 1917, the post office was located on Anderson Run Road in this house. It was attached on the right side. The postmaster C. Frank Mizer is shown with his wife, Leota, and son Russell standing in the front yard. (Courtesy of Twila Mizer Morningstar Bodle.)

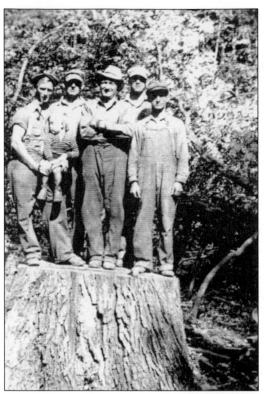

LUMBERJACKS. In 1945, these Fallsburg lumberjacks cut down a huge tree. Proud of their laborious task, they had their photograph taken standing on the stump. Pictured from left to right are Pete Evans, Guy Bucy, Bill Parr, unidentified, Lester Clark, and child Dwight Evans. (Courtesy of Carolyn Anderson Clark.)

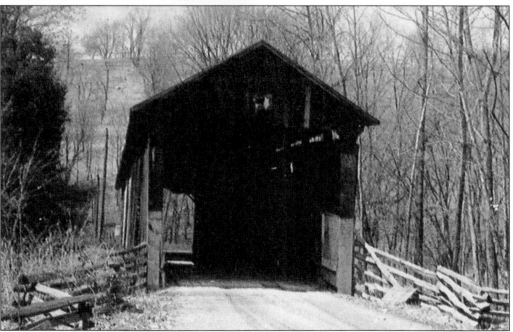

GREGG'S MILL COVERED BRIDGE. This bridge over Wakatomika Creek has stood the ravages of time and many floods. It is located on County Road 201, just one mile north-northwest of Fallsburg. The county was once home to numerous covered bridges, but very few remain today. In the mid-1800s, many mills thrived along the creek. (Courtesy of Charlie and Ruth Hancock.)

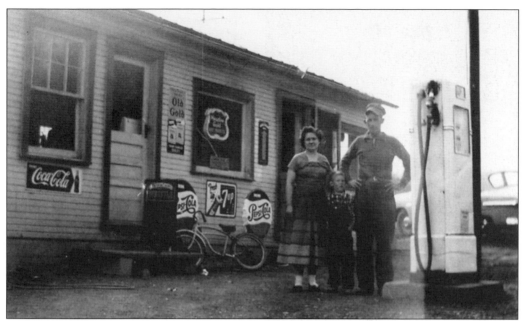

FALLSBURG GENERAL STORE. Joe and Cordelia Kirk (Corky) Cunningham are shown standing in front of their general store located on Route 586. They were the proud owners from 1945 to 1957. It changed hands many times after 1957, and the last business in the building was the C and I Restaurant owned by Cecile Shoemaker. It has since been converted into a private residence. (Courtesy of Joe and Cindy Cunningham.)

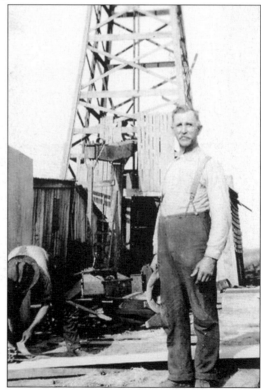

OIL BOOM IN FALLSBURY TOWNSHIP. William Beckham stands by an oil rig in 1917. To obtain the oil from deep within the ground they "shot the well" by dropping dynamite into it. Townspeople overlooking the village and valley from the Fallsburg Cemetery could count over 30 oil well rigs in the distance. (Courtesy of Karen Beatty Ashcraft.)

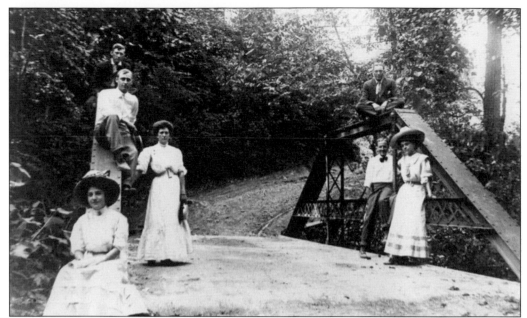

CAMP WAKATOMIKA. With the dedication of Ruth Shollenbarger in 1942, the Newark area Girl Scout Council purchased 260 acres of eroded farmland and deep woods to be used as a summer camp for Girl Scouts. Today the curriculum focuses on camping and enriching outdoor programs to help girls grow strong. Their sessions offer a variety of opportunities and all things that create the magic of summer camp.

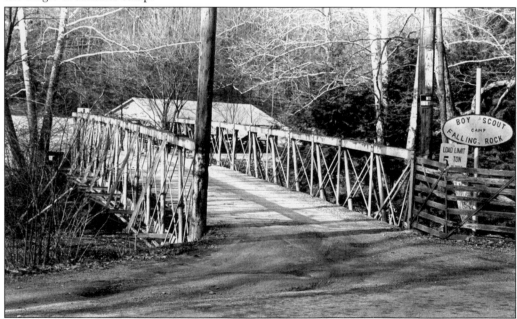

BOY SCOUT CAMP FALLING ROCK. Not to be outdone by the Girl Scouts, the Boy Scouts also have their own camp. Camp Falling Rock is located 11 miles north of Newark off Route 79. More than 600 acres provide a setting of rolling hardwood forests, streams and waterfalls, and scenic meadows. This bridge was moved from Hebron, where it once carried travelers across the historical canal. This photograph was taken in 1992.

Four

MONROE, LIBERTY, JERSEY, AND ST. ALBANS TOWNSHIPS

Coming from Green County in Pennsylvania in 1806, George Washington Evans and his wife, Lucy, were the first to settle in Monroe Township. It was later organized in 1812. Early settlements included Eden Cross Roads, Green, Moses, Raccoontown (an original Wyandot Indian village), and Twelve Corners.

Created from the eastern half of Monroe Township in 1827, Liberty Township was among the last in the county to be organized and settled. In 1818, the Stephen Emerson family was the first to make their home, followed three years later by Rena Knight. Early settlements included Brooks Corners, Concord, and New-Way.

In 1815, Peter Headley built a cabin and moved in one year later, becoming one of the first pioneers of Jersey Township. The township was organized in 1820. Early settlements included Ashbrook (thought to be in Jersey Township), Beech, Beechland, Headley's Mills (now known as Jersey), Millers Corners, Panhandle Corners, Parkhurst Corners, and St. Joseph.

The first settlers of St. Albans Township were the John Cooke Herron family in 1807. The township was organized in 1813. Early settlements included Alexander (now Alexandria), Ash, Bloodhill, Clemons Mills, Goddard Corners, Hazleton Corners, Reeses Corners, Scotts Corners, and Taylors Corners.

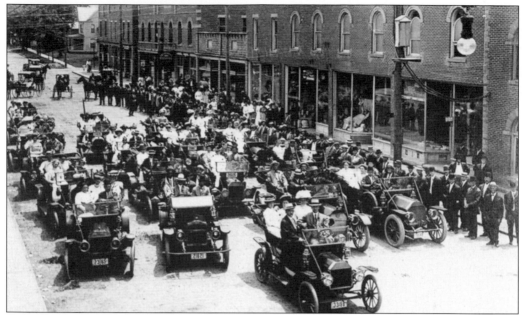

JOHNSTOWN RALLY ON MAIN STREET, 1911. William A. Ashbrook is riding on the right in the front car. He served as a U.S. congressman from 1907 to 1921, and from 1935 to 1939. He was serving his 10th congressional term when he died at his Johnstown home in 1939. When Ashbrook, the talented young editor of the *Johnstown Independent*, was married to Jennie B. Willison in 1889, it was a notable society event.

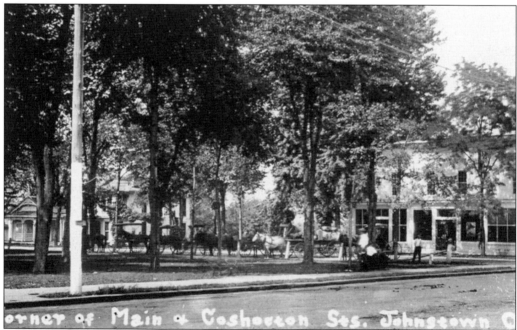

CORNER OF MAIN AND COSHOCTON STREETS. Before the automobile arrived on the scene and changed lives forever, horses and buggies were the principal means of transportation and would line the streets, as shown in this scene on Coshocton Street in Johnstown. The photograph was taken in the late 1800s or very early 1900s.

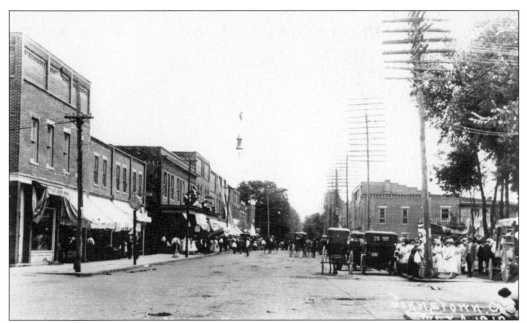

LOOKING EAST ON MAIN STREET. Crowds anxiously await the sights and sounds of the Fourth of July parade on Main Street in Johnstown. Some even sit atop the balconies of the buildings to get a better view. In 1912, only the very well-to-do could afford the "horseless carriages" seen parked along the side of the street. The fancy streetlight hanging from a cable over the center of the street would have given only minimal light.

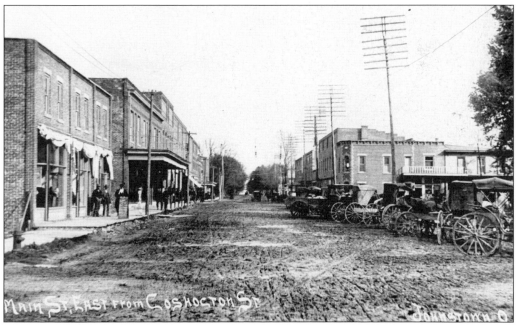

MAIN STREET EAST FROM COSHOCTON STREET. Another view of Main Street in Johnstown gives an idea of city traffic during the early 1900s. It must have been extremely difficult driving through the mud on the dirt streets, especially in winter. And the parking was even more so. It appears some people parked their buggies as haphazardly then as some park their cars today.

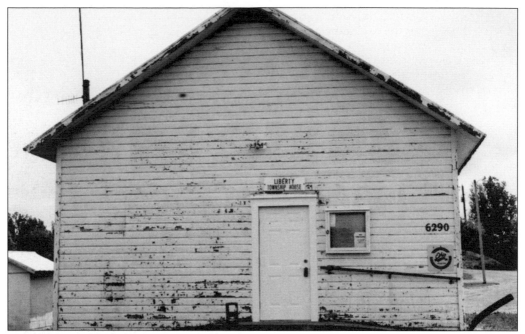

LIBERTY TOWNSHIP HOUSE. Not much is known of the history of this old tin-roofed building that serves as the Liberty Township House. But it still stands proudly on the corner of Northridge Road and Sportsmans Club Road, not far from the highest point in Licking County at 1,360 feet above sea level.

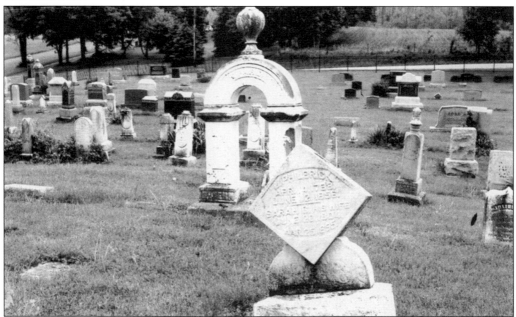

CONCORD CEMETERY. Licking County is home to many old cemeteries. At least three in Liberty Township were in existence in 1888. This old one at Concord gives an insight to the symbolic statements made after death. People honor loved ones by choosing just the right monument and hope that it will stand forever. As these stones are viewed, one can not help but wonder just who these people were and what their lives were like.

PRESBYTERIAN CHURCH. Still standing in Jersey Township is the old Presbyterian Church built in Jersey in the 1840s. As with many churches with tall stately steeples, this one too succumbed to a lightning strike. This historic church is now home to the Faith Bible Church.

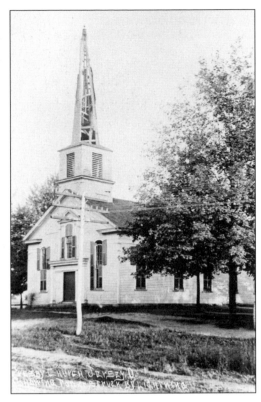

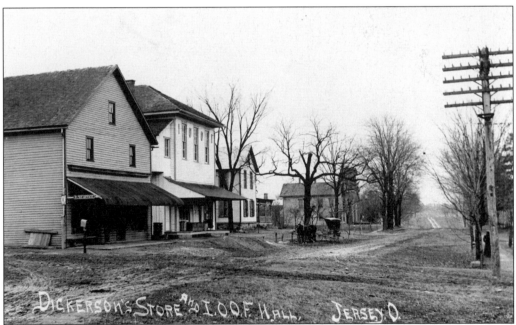

DICKERSON'S STORE AND INDEPENDENT ORDER OF ODD FELLOWS HALL, JERSEY. Nowadays, Morse Road provides two paved lanes of highway through Jersey and looks much different than it did in the early 1900s. This old dirt road brought customers to Dickerson's Store and club members to the International Order of Odd Fellows hall. Both of these buildings burned in the fire of 1911.

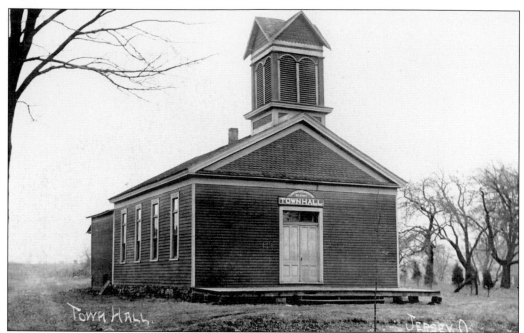

JERSEY TOWN HALL. The Jersey Town Hall, adorned with a large cupola, is dated 1897. It is located on Morse Road and is now a private residence.

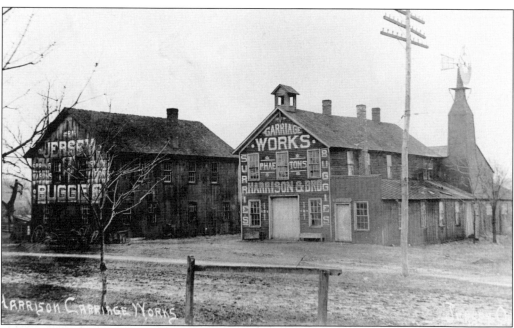

HARRISON CARRIAGE WORKS. From 1878 to 1928, the Harrison Carriage Works in Jersey built buggies and phaetons, described as a light, four-wheeled carriage, drawn by one or two horses, with front and back seats and, usually, a folding top. The design of the structure is unusual with the large windmill on the side. Could this have provided power for the machinery inside the building?

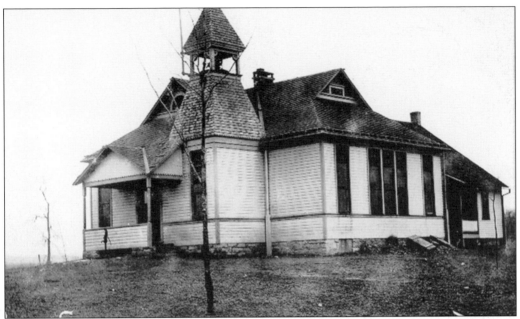

JERSEY PUBLIC SCHOOL. This frame school building of an interesting design stood on Morse Road. The date of this photograph is unknown, but what is known is that sometime during 1911 the building was moved to its new "downtown" location in Jersey, where it served as a general store until it burned in 2007. (Courtesy of West Licking Historical Society.)

VIEW OF JERSEY. With the old country road, picturesque buildings, and corn shocks in the background, this view looking from the top of the hill just west of town certainly would have made for a beautiful autumn Sunday afternoon drive in the old horse and buggy. (Courtesy of West Licking Historical Society.)

JERSEY STORE. This store located in downtown Jersey was subject to a suspicious fire in 2007, when the building burned. This important corner is now awaiting whatever may be next. The store was originally the old frame school in Jersey and was moved to this location in 1911. (Courtesy of West Licking Historical Society.)

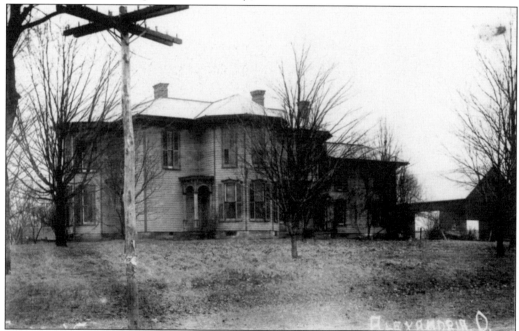

SCOTT'S CORNERS. In the 1870s, Capt. Joseph M. Scott built this house at the corner of State Routes 161 and 37, located in St. Albans Township. Due to new highway construction, the house was recently moved in 2007 from Scott's Corners to the site of the former Brookside Dairy Farm west of Alexandria. (Courtesy of Karen Holt.)

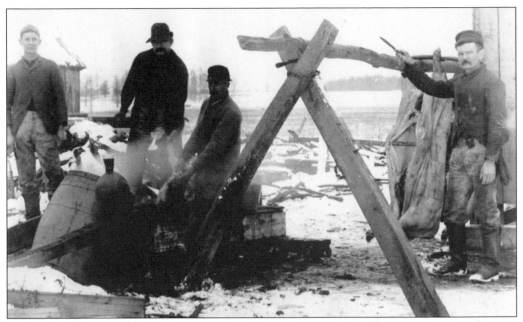

HOG KILLING. It has been a necessary tradition for the people of this country to use whatever means to provide food for their families. Pictured are H. Hubbard, Austin Stimson, Harry Hubbard, and John Hubbard at a wintertime hog butchering on their St. Albans Township farm one-half mile west of Alexandria, currently owned by Charlie Reeves. (Courtesy of the Alexandria Museum.)

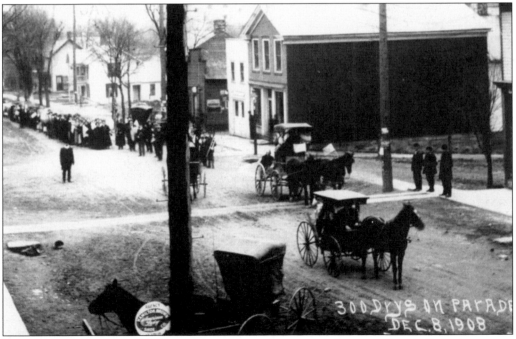

DRYS PARADE. In 1908, 300 "drys" met to protest the rowdy influence of beer halls in downtown Alexandria. Especially notorious was Tater Hole in the basement of the hotel. The parade is pictured here on East Main Street in downtown Alexandria. (Courtesy of the Alexandria Museum.)

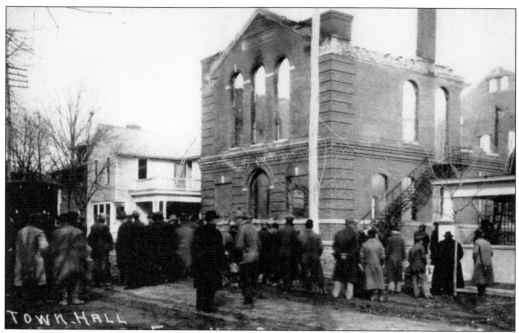

TOWN HALL FIRE. The November 26, 1926, Alexandria Town Hall fire was caused by an arc lamp projector igniting the nitro-gelatin film in the auditorium on the second floor during the showing of an early silent film. The building was only 11 years old and was located on West Main Street. (Courtesy of the Alexandria Museum.)

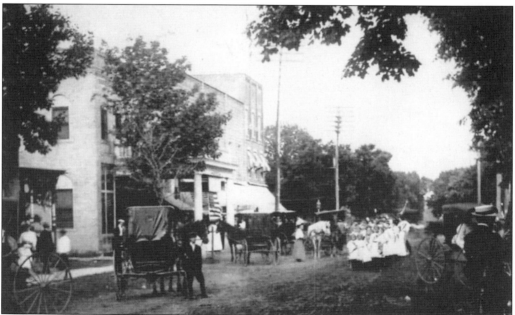

DECORATION DAY (MEMORIAL DAY). Now, as in 1908, people gather to honor loved ones who have passed. Most villages hold a parade through town to the local cemetery where they hear speeches by local dignitaries giving homage to veterans who have died. This shows the parade on West Main Street in Alexandria looking east in front of the Buxton House Hotel. (Courtesy of the Alexandria Museum.)

Five

McKean, Newton, Granville, and Newark Townships

Settled first by John Price in 1806, McKean Township was organized and held its first election in 1818. Early settlements included Cokesbury (also Cokesbury Corners), Edelblut Corners, Fredonia, Gosnell's Corners, Gomorrah, Mount Herman, Sodom, Sunnyside, and Sylvania (now known as Highwater).

John Evans came from Virginia in 1803 and settled in Newton Township. His brother was the first to settle in Monroe Township. The township was organized in 1809, and early settlements included Cannonsburg (also known as Fairfield), Chatham (also known as Chattertown, Harrisburg, and Norman), Houston (known also as Houston Mills and Newton Mills), and Vanattaburg (now known as Vanatta).

First settled by John Jones, Patrick Cunningham, and others in 1801, Granville Township was organized in 1807. The township is home to Alligator Mound, a historic 200-foot-long effigy mound. Early settlements included Blanchard Settlement, Centerville, Central City, Clemons, and Welsh Hill Settlement (2,000 acres of land purchased in 1801 by Thomas Phillips and Teaphilus Rees).

One early setter of Newark Township in 1801 was Samual Parr. The township was not organized until June 1810 but was surveyed in 1797 by John G. Jackson. Early settlements included Baltmore, Dogtown (legend says the area was home to a race of half animal/half humans), Fleming, (also known as Havana, Hollister's Mill, Natchez Under the Hill, and now as Hanover), Hayesburg, Kibler, Lockport, and Maholm.

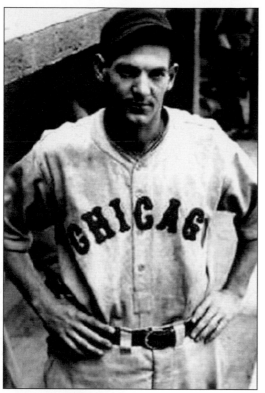

ELWOOD "WOODY" GEORGE ENGLISH. Elwood "Woody" English was born in Fredonia. His first professional job was with the Toledo Mud Hens in 1925. In 1926, he was sold to the Chicago Cubs for $50,000. Woody played in two major-league World Series with the Chicago Cubs, losing both. After retiring from playing, Woody managed the Grand Rapids Chicks of the All-American Girls Professional Baseball League for three years. (Courtesy of Phil Waite.)

HILLCREST GOLF COURSE. Licking County is home to 18 golf courses, including the famed championship Longaberger Golf Club designed by Arthur Hill. It is also home to many golf club manufacturers. The Newark companies GolfWorks, Dynacraft, and Toski Golf's roots were in the Burke Golf Company, a golf club–manufacturing business that was an offshoot of a buggy-whip maker.

St. Luke's Lutheran Church, Vanatta. St. Luke's Lutheran Church, with its bright red doors, arched windows, and enclosed bell tower, has been a foundation block in this small friendly community for more than 100 years. The church building was dedicated on August 23, 1896. In 2007, the congregation will celebrate its 150th year.

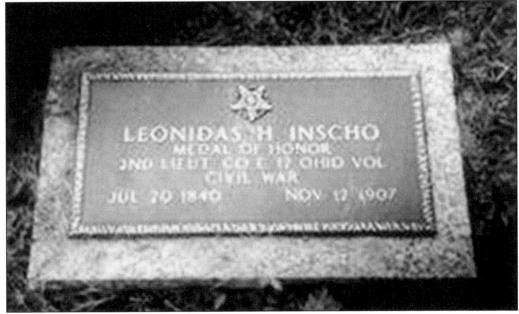

Leonidas Inscho. Corp. Leonidas Inscho of Company E, 12th Ohio Infantry was awarded the Congressional Medal of Honor for action in the Battle for South Mountain, Maryland, on September 14, 1862. He was born in Chatham. The citation was issued on January 31, 1894. Alone and unaided, and with his left hand disabled, he captured a Confederate captain and four men. He is buried in Cedar Hill Cemetery in Newark.

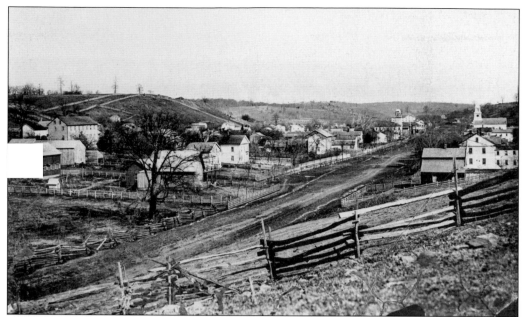

GRANVILLE SCENE. This photograph was probably taken about 1868 and shows Granville in its earliest days. In the far distance is the tower of St. Luke's Church. The village had already become established as an educational center. The photograph shows the unpaved Broadway with the absence of people and horses, but it is already obvious that the New England influence of architecture was used.

WELSH HILLS SCHOOL BRICK BUILDING, 1899–1981. The rural Welsh Hills School was an institution of great importance to its former pupils and teachers and held many affectionate memories. Before 1825 there was no public education, as is now known, in Ohio. Such schools as there were, were maintained by subscription or by local taxation. The tax paid amounted to "so much per head" for each child that a family sent to school.

BROADWAY IN GRANVILLE. The village has not changed much since this photograph was taken. With the exception of the interurban tracks and of course newer model automobiles, the wide tree-lined street in Granville remains the same picturesque New England–styled village as is shown here. The Licking Company met in the new log school in 1806 and voted that "the name should be called Granville." (Courtesy of Tim Bubb.)

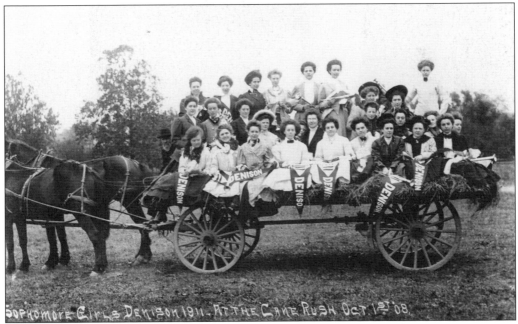

SOPHOMORE GIRLS DENISON. Granville is home to Denison University. Numerous celebrities have been associated with Denison. Among them are Hal Holbrook (actor), John Davidson (singer), Joel Grey (entertainer in *Cabaret*), Michael Eisner (Disney executive), and Woody Hayes (Ohio State University head football coach).

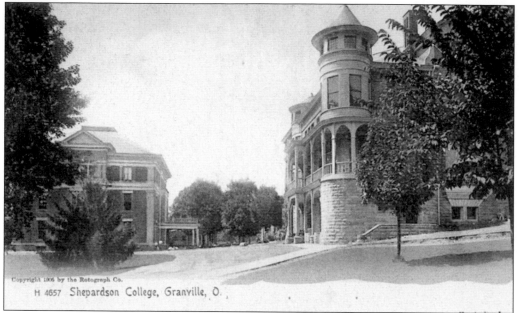

H 4657 Shepardson College, Granville, O.

SHEPARDSON COLLEGE, GRANVILLE. Rev. Daniel Shepardson, D.D., founded Shepardson College at Granville. In 1868, Dr. Shepardson came to Granville, where he purchased from Rev. Marsena Stone the Young Ladies' Institute, and for 19 years he conducted this school as a private enterprise. In 1887, he gave the school to the Baptist Church. For many years he was also a trustee of Denison University.

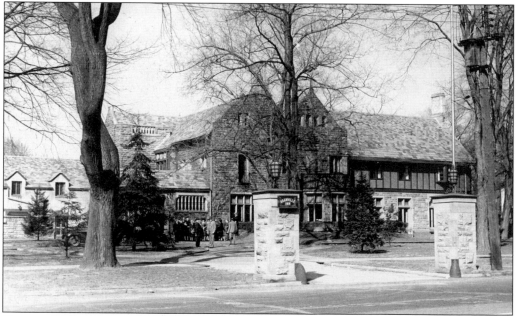

GRANVILLE INN. The Granville Inn sits on the site of the old Granville Female College that was organized in 1827 and operated until 1898. The inn opened its doors to the public in June 1924, with a reception for the residents of the village. Approximately 2,000 people attended and were served a buffet supper. After dinner there was dancing on the wide terrace and the paved patio. (Courtesy of Tim Bubb.)

IDLEWILD PARK. In the late 1800s and early 1900s, the Idlewild Park had five lakes on which to boat, a bathhouse, a summer theater, bike races, a bowling alley, a billiard hall, a shooting gallery, a switchback, a casino, sulky races, music, a dance hall, a first-class hotel and restaurant, other amusements, and of course, refreshments of all kinds. The park is now a peaceful, beautiful place known as Moundbuilders Park.

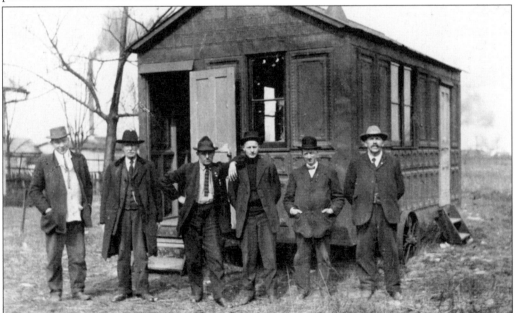

THE WAY ONE VOTES, 1912. When Woodrow Wilson was elected president, Licking County voters used portable election houses, such as this one pictured, to cast their ballots. The houses were towed to precinct polling places throughout the county. From left to right are Harry Ballenger, Daniel Gormely, Henry Gartner Jr., Frank W. Woverton, Albert Johns, and Henry Gartner Sr.

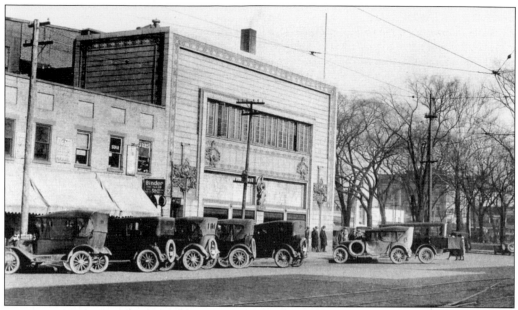

SULLIVAN BUILDING. Louis Sullivan, one of America's most-famous architects, is best known for his designs of "jewel box" banks. The Old Home Bank in Newark, one of several built by Sullivan, was built in 1914 and is the only one that is totally terra-cotta. His buildings have been preserved in Chicago and the Midwest. This photograph, taken on West Main Street, shows the interurban tracks and cars of the 1920s.

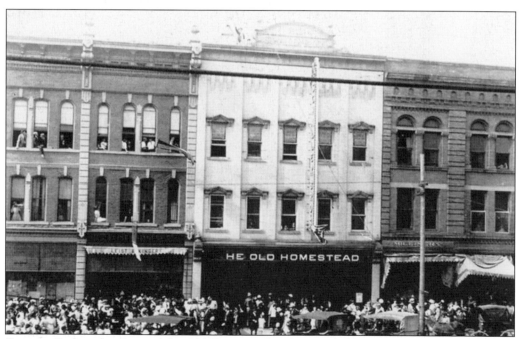

CROWD. Gathered in front of the Old Homestead in downtown Newark, hundreds of people are gathered to watch the tight-wire walker on the top of the building. Some are even hanging out of the windows just to get a glimpse. One wonders what the occasion might have been to bring in such a crowd.

SHOPPING IN DOWNTOWN NEWARK. Downtown Newark was a beehive of activity in the 1930s, 1940s, and 1950s. The majestic Soldiers' and Sailors' Memorial Building shown at the top right was built in 1895 to honor the dead of the Civil War and opened with the Newark Opera Club performing the *Pirates of Penzance*. It has been razed and is today the site of Foundation Park. (Courtesy of Tim Bubb.)

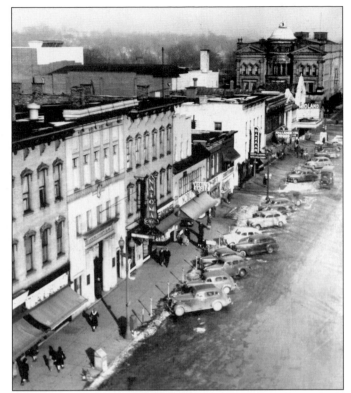

JOHN J. CARROLL'S DEPARTMENT STORE. Long before the days of shopping malls, shoppers went to upscale department stores like this one. J. J. Carroll was established in 1898 and made a specialty of the mail-order trade that extended all over the United States. Carroll had two previous locations before locating on North Third Street. The building still stands, but the business is long gone. (Courtesy of Tim Bubb.)

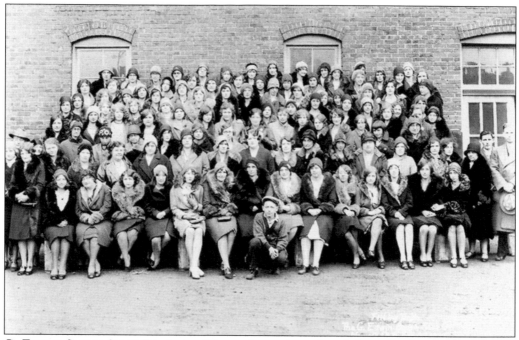

G. Edwin Smith Shoe Company. Women have always loved shoes. But how many of them have ever made their own? These ladies are working in the fitting department of the G. Edwin Smith Shoe Company in Newark on February 27, 1930.

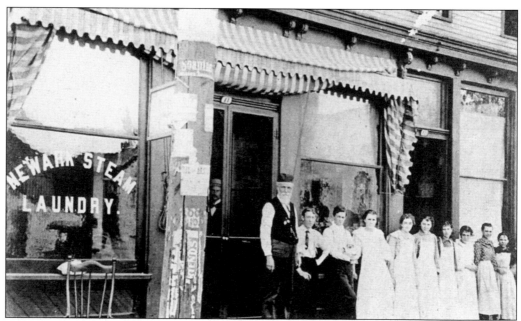

Newark Steam Laundry. Prior to the days when most have their own washers and dryers, there were many downtown laundries. In 1893, the Newark Steam Laundry was located at the northwest corner of Fourth and Church Streets. Other laundries in Newark at that time were the George Bowers Laundry, Chong Lee Laundry, Charles Lewis Laundry, White Cloud Laundry, and the Hop Sing Laundry.

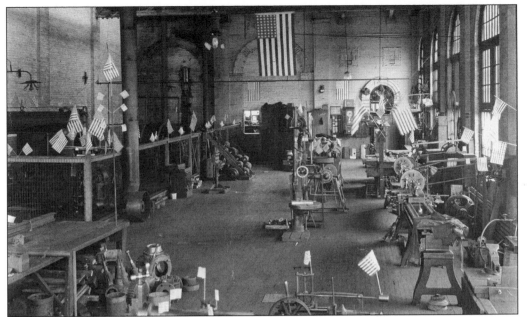

WEHRLE FACTORY. The Wehrle Stove Company was established in 1883 and became the largest stove foundry in the world. In 1907, the company employed 3,000 workers and had the ability to manufacture 900 stoves a day in the mammoth plant. Situated on 15 acres, there were two plants and two miles of private railway siding. At one time the two factories used 75 railcars. (Courtesy of Tim Bubb.)

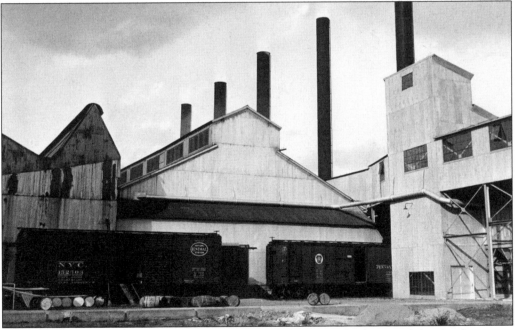

OWENS CORNING FIBERGLASS. Train cars are pulled up to unload material for the factory in the mid-1950s. The location of the Owens Corning Fiberglass factory has a long and fascinating history beginning with the Newark Star Glass Company factory in the 1880s. The plant today is one of Licking County's largest employers. (Courtesy of Tim Bubb.)

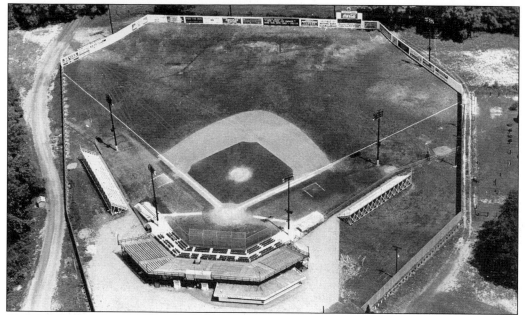

ARNOLD PARK. Arnold Park opened in August 1947 with seating for 2,700, a 10-foot-high outfield fence, and lights for night games. The opening game was between the Newark Browns and Springfield. The Browns won 4-3 before 1,947 fans. Minor-league baseball was played until 1951, when the program died after the Newark Baseball Club folded. Ironically, 1951 was when Little League baseball debuted. (Courtesy of Tim Bubb.)

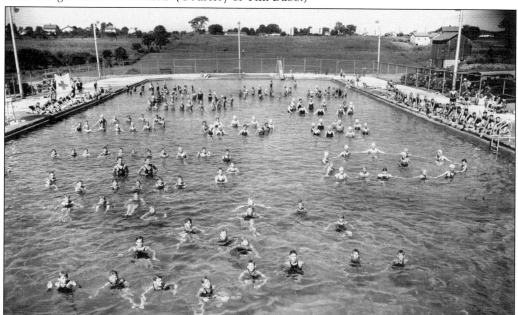

MUNICIPAL SWIMMING POOL. On August 20, 1932, over 400 people turned out to swim as Newark opened the new municipal swimming pool at Hollander Street and Water Works Road. This pool is still in existence and is now known as Hollander Pool. The photograph, taken in the mid-1950s, shows the swimming and life-saving classes being taught by the American Red Cross. (Courtesy of Tim Bubb.)

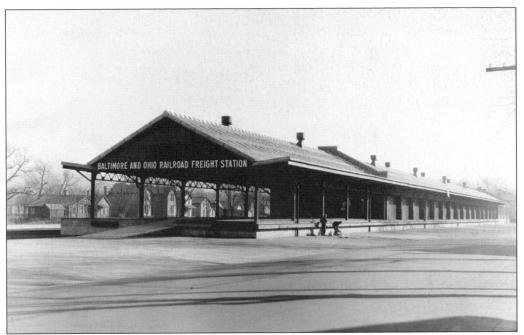

B&O FREIGHT STATION. Shown is the newly built freight station of the Baltimore and Ohio Company. The first railroad to pass through Newark was the Sandusky, Mansfield and Newark Railroad in 1852. The B&O moved its headquarters to Newark in 1871 and became the largest employer in the city at that time. (Courtesy of Tim Bubb.)

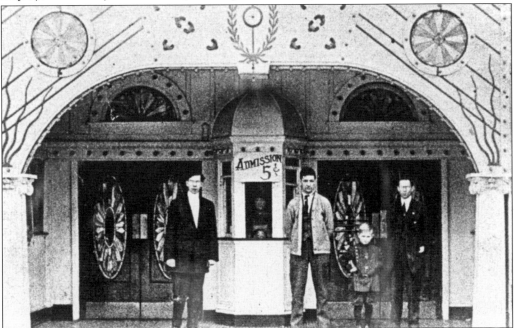

UNKNOWN THEATER. This was just one place Licking Countians could go to see the latest in moving pictures. During the early part of the 1900s, downtown was home to many many theaters and music halls. Among them were the Orphium, Bijou, Empire, Grand, Lyric, Alhambra, Gem, and Rex theaters. At this one, one could enter the world of magic for 5¢.

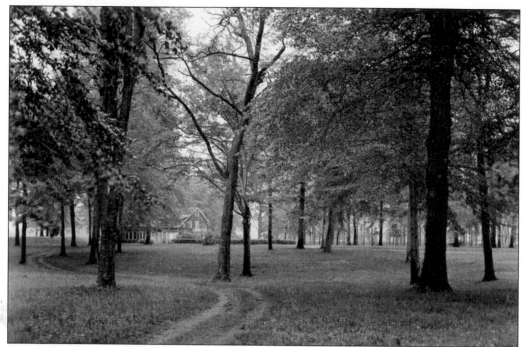

MOUNDBUILDERS COUNTRY CLUB. In 1910, the board of trade leased the encampment grounds to the Licking Country Club Company at a cost of $650 per year and the country club was immediately organized. A year later, Newark's Country Club house was built at a cost of $12,000, and it opened on June 15. (Courtesy of Tim Bubb.)

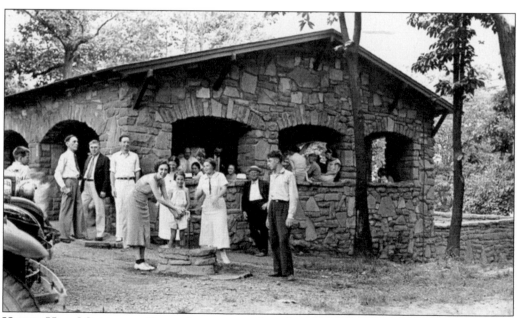

HORNS HILL MUNICIPAL PARK. A group is gathered at the shelter house for a day of fun and fellowship at the park. The park sits atop a tree-lined hill on the north side of Newark. (Courtesy of Tim Bubb.)

FIRST PRESBYTERIAN CHURCH.
Rev. John Wright organized
the First Presbyterian Church
in Newark in 1808. The first
installed pastor was Rev. George
Van Enman in 1809. The First
Presbyterian Church is considered
the first church in Newark and
will celebrate its 200th birthday
in 2008. The current building, as
shown in this photograph, was
designed by Mansfield architect
Vernon Redding and built in 1909.

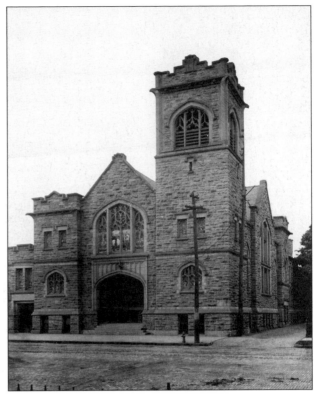

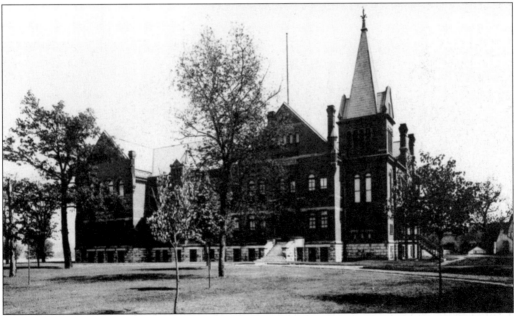

OLD CHILDREN'S HOME. This Richardsonian Romanesque building was designed by J. W. Yost and built for $65,000. The fireproof building won an award at the World's Columbia Exposition for the "most modernly equipped and efficiently run institution of its kind in the world." The home closed in 1975. Eligible for listing on the Ohio Historic Preservation of Historical Places, there has been talk of tearing the home down.

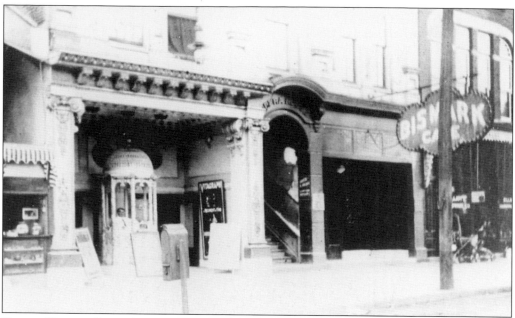

OPERA HOUSE. Opera houses were popular in the late 1800s and early 1900s. World-famed Russian ballet star Madam Olga Petrova became the bride of Dr. John B. Stewart in 1914. Dr. Stewart grew up and began his medical practice in Licking County. When Dr. Stewart was house surgeon at an Indianapolis hospital, Petrova fell during a performance and suffered torn ligaments. Dr. Stewart operated on her, they fell in love, and the rest is history.

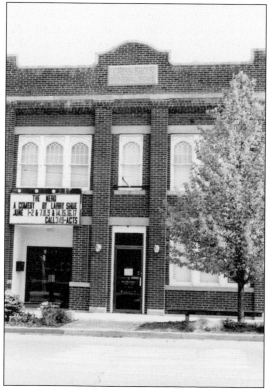

LICKING COUNTY PLAYERS. The Licking County Players have been in existence for 40 years. It began as the Welsh Hills Players and was changed to Licking County Players to enhance an image of a wider theater audience. In 1996, the group purchased the former Criss Brothers Funeral Home and now operates year-round with a full schedule including eight performances, suitcase and dinner theaters, and children's workshops.

Six

MARY ANN, PERRY, MADISON, AND HANOVER TOWNSHIPS

A Mr. Bush from Virginia was one of the first to settle in Mary Ann Township in 1809. After Bush died, his widow moved from their home and Hugh Doran moved into the cabin. The township was organized in 1817. Some early settlements were Hickman, Nicholastown (also known as Chickenville and Rocky Fork), and Wilkins Run (also known as Dudgeon's Corners and now known as Wilkins Corners).

Samuel Hickerson was the first settler in 1810. Perry Township was organized in 1819. Some early settlements were Brushy Fork, Cooksey (now known as Reform), Denman's Crossroads, Elizabethtown (now known as Perryton), Hickman, and Mary Ann. Perryton was named for Commodore Perry.

The first settlement of the county took place in Madison Township. In 1798, Elias Hughes and John Ratliff settled there. The township was organized in 1812. Early settlements were Ben, Pleasantsville (known also as Claylick Siding and now as Claylick), Hammertown, Irwin, Lockdale, Montgomery (now thought to be Marne), Pleasantsville, Swans, and Weiant.

Philip Barrack was probably the first permanent settler in Hanover Township in 1801. The township was organized in 1808. Early settlements were Blackhand (now Toboso), Boston, Hoyt, and Fleming (also known as Hollister's Mill, Natchez Under the Hill, and now as Hanover).

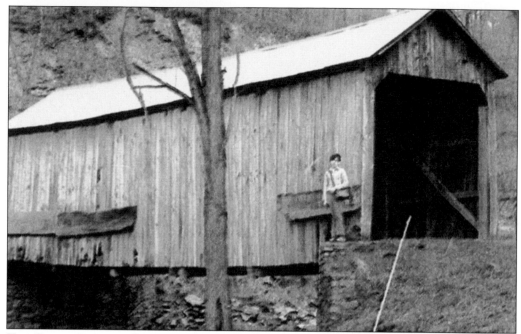

THE DAVIS COVERED BRIDGE. This bridge that spans Rocky Run in Mary Ann Township is located just one-half mile south of the village of Hickman and is described as a Multiple King Post. The bridge measures 50 feet long and was built in 1947. (Courtesy of Charlie and Ruth Hancock.)

ROCKY FORK STORE. Wilkins Corners in Mary Ann Township is located at the intersection of Purity Road and State Route 79 and is named for Henry and Daniel Wilkins. Henry erected a gristmill near the forks of Lost Run in 1830. About 1858, James Randall established a store at the corners. Two years later he sold the store to William Dudgeon. Dudgeon opened a post office in the building that remained opened until 1895.

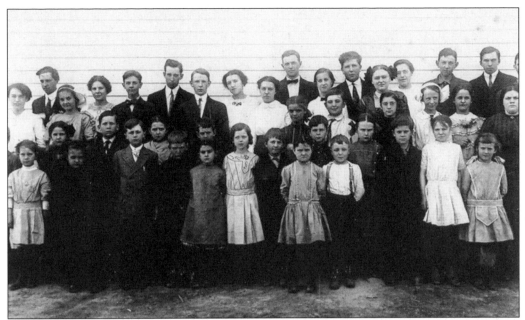

PERRYTON SCHOOL. The Perryton School in 1912–1913 had grammar, primary, and high school students in one building. Although it is hard to tell which were teachers and which were the older students in this photograph, one thing for certain is either the youngest students were unhappy with school or with having their photographs taken, especially the little girl in the first row.

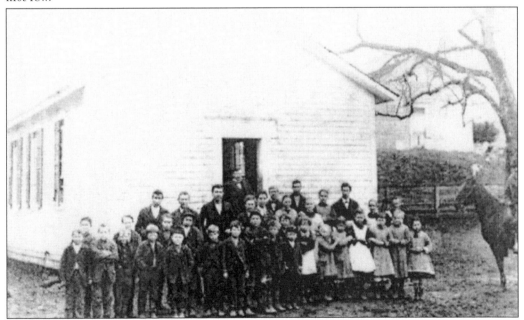

BRUSHY FORK SCHOOL. Once again these schools dotted the county during the late 1800s and early 1900s. As one can tell from the photograph, the little girls in the first row were all friends because they have their arms linked. The boys and the girls are separated, with the exception of a couple of males in the back who appear to be teachers. The school building still remains and is the site of an antique store.

WARREN S. WEIANT SR. Warren S. Weiant Sr. was a genius. He started a coal company, the Hudson Avenue housing development, and the Newark Lumber Company. He also founded the Newark Auto Coach Company, the Newark Telephone Company, and the Weiant Bakery (it later became a branch of the National Biscuit Company, now known as Nabisco). (Courtesy of Sue Williams.)

SURVIVOR OF THE TITANIC. Edmund Williams is seen here with his great-grandmother Mrs. John C. Hageboom. On April 16, 1912, the newspaper reported, "The mother of Mrs. Carl R. Weiant of Newark – Mrs J. C. Hageboom, Mrs. Weiant's aunt, Miss Cornelia T. Andrews, and a cousin, Miss Gretchen Longley, are among the passengers saved when the Titanic hit an iceberg and sinks with 1,503 doomed passengers." (Courtesy of Sue Williams.)

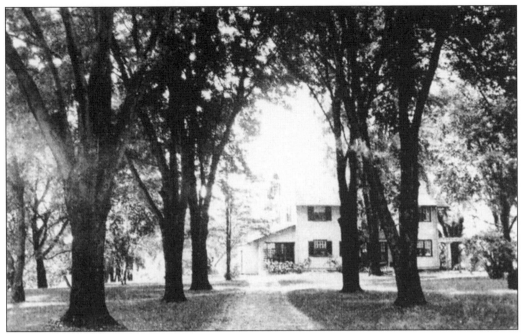

HOME OF WARREN S. WEIANT SR. Weiant wanted to get back "on the farm" when he purchased 100 acres of farmland four miles east of Newark. The Weiants' original house in Madison Township (shown) was built in 1897 on Marne Road. The addition was added on to the home in 1907. (Courtesy of Sue Williams.)

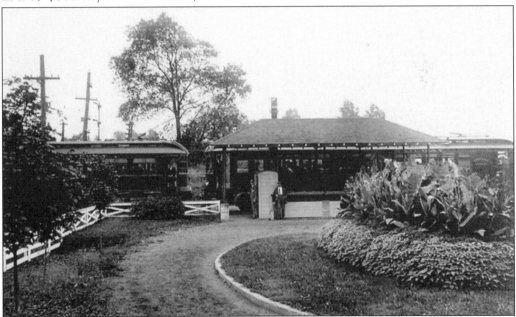

WEIANT RAILWAY STATION. The farm was located near the canal and the railroad tracks. The beautiful "black muck" soil was ideal for growing celery and other vegetables. By 1906, Weiant's business, known as Little Kalamazoo Celery Farm, shipped its first produce. A station and tracks were built just to bring the workers to the greenhouses. The station was located behind the house. (Courtesy of Sue Williams.)

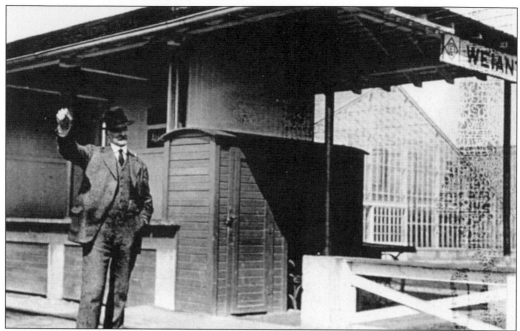

WEIANT STATION. Warren S. Weiant Sr. is seen standing on the station platform. By 1922, the company had four acres of narrow Dietz-style greenhouses, a coal tipple with siding along the railroad, two rose greenhouses of one acre each, a new power plant, a new packinghouse, and a one-acre steel-framed greenhouse. (Courtesy of Sue Williams.)

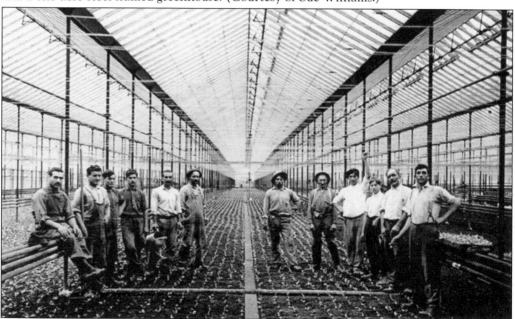

WEIANT GREENHOUSES. Weiant and his eldest son Carl A. formed the Warren S. Weiant and Son Company. The gardens were known nationally as the largest such facility with seven acres under glass, all heated. Weiant had no trouble getting workers. The railroad had a large number of Italian farmers working outdoors. After one cold winter, it took little to convince them to work in the warm greenhouses for the same pay. (Courtesy of Sue Williams.)

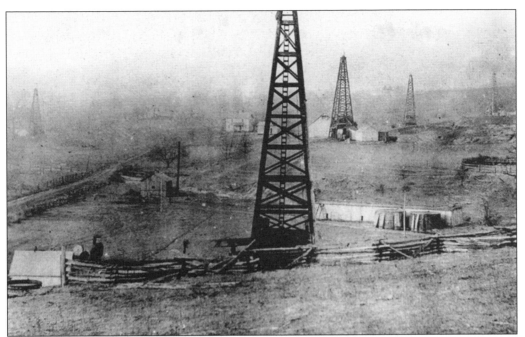

OIL FIELDS. Many do not know that Licking County was a huge producer of oil and gas wells in the early 1900s. Here the oil wells in Hanover Township dot the countryside. With the available natural resources like natural gas, crude oil, and coal, many industries located and prospered here.

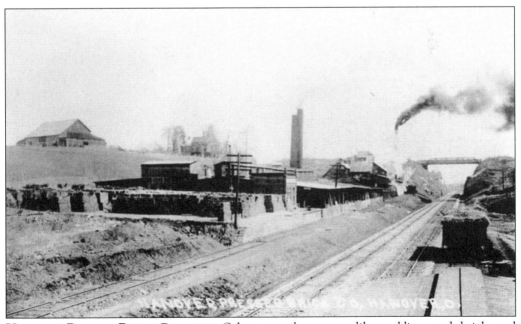

HANOVER PRESSED BRICK COMPANY. Other natural resources like molding sand, brick, and pottery clay are also abundant in the county. Bricks are still being made today in Hanover at the Bowerston Shale Company.

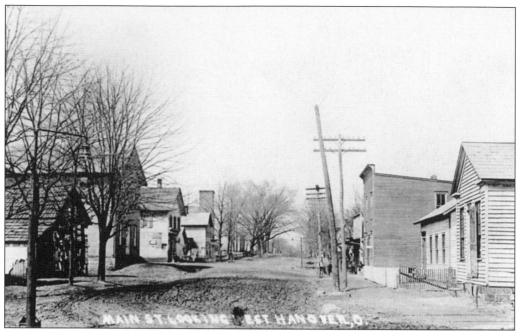

MAIN STREET LOOKING WEST IN HANOVER. Hanover still remains the quiet village it was when this photograph was taken before paved streets. A small boy can be seen in the distance peeking around the crooked pole at the camera. He appears to be standing in front of a store.

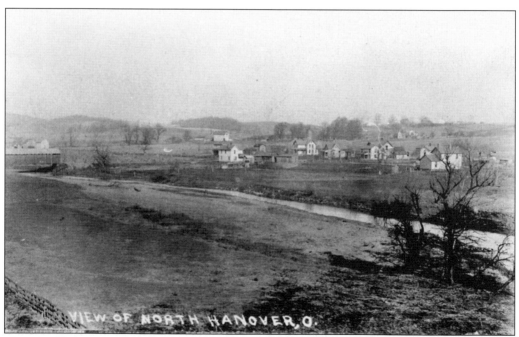

VIEW OF NORTH HANOVER. No Norman Rockwell picture could ever be as charming as this photograph of Hanover. From the covered bridge and creek in the foreground to the white village homes, the view is postcard picture perfect. The date is probably early 1900s.

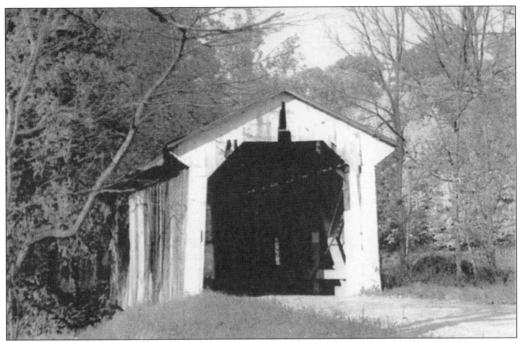

BUGGARD HILL COVERED BRIDGE. This bridge that spans Brushy Fork, located two and one-half miles south of Hanover, was built in 1872 and stands 52 feet long. (Courtesy of Charlie and Ruth Hancock.)

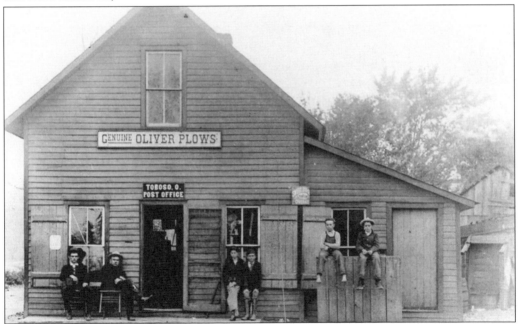

TOBOSO POST OFFICE. The village of Toboso (once called Black Hand) came into being in 1852, when William Stanberry laid out the town. Crumel Fairbanks built the first house and started a grocery and a saloon. The post office was established in 1854, with E. Hicky as the first postmaster. It was once closed in 1855 but reopened in 1858, and remained so until 1957 when it was closed for good.

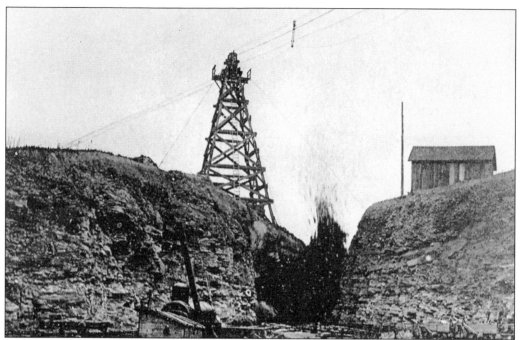

E. H. Everett Sand Rock Quarry. Located near Black Hand Gorge in Hanover Township, the sand rock quarry helped make the area a commercial site. In the background one can see an "explosion" of rock and sand.

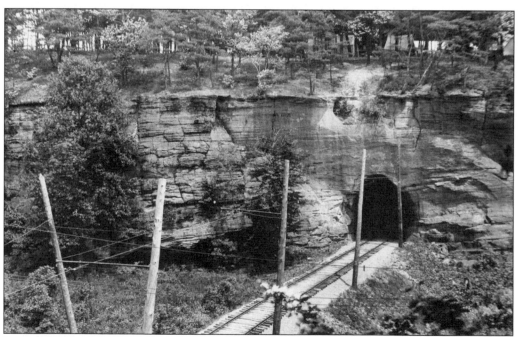

Black Hand Gorge Unique Tunnel. Bored through solid rock, this tunnel near Toboso was the only such interurban tunnel in the nation. Atop the huge rock at Black Hand Gorge was a popular resting point that became known as Picnic Rock. One can see the tents set up at a campsite.

Seven

LIMA, HARRISON, AND ETNA TOWNSHIPS

In the late 1800s, Lima Township was known as one of the finest townships in the county. David Herron was the first to settle there in 1805. The township was organized in 1827 but was dissolved in 1996, when it was established as the city of Pataskala. Some early settlements included Columbia (known now as Columbia Center), Conine (also known as Conineville and now Pataskala), Fursville, Hawkeye (now Summit Station), and Moreland Cornors.

The Henry Drake family is thought to be the first family to settle in Harrison Township in 1806. The township was originally a part of Union Township and organized in 1816. Early settlements included Belfast, Kirkersville Station (which is now called Outville), and Wards Corners.

Located in the southwestern corner of the county, Etna Township was known as the "Refugee Lands." Etna Township was first settled in 1815, when John Williams first began clearing the land. The township was organized in 1833, when the first election was held at the home of John Henthorn. Some early settlements were Chamberberg, Carthage (known first as Moriah and now Etna), and Cumberland (now known as Wagram).

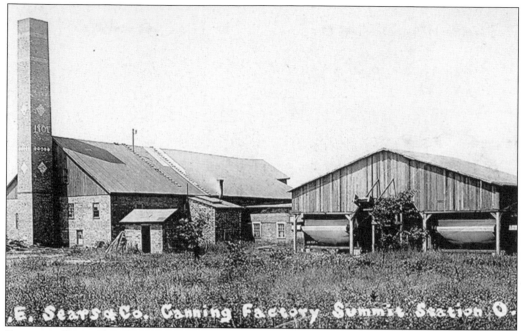

SUMMIT CANNING FACTORY. The Sears and Company canning factory was located in Lima Township near Summit Station. The building was probably built in 1901 since the chimney exhibits that date. The photograph was taken about 1912. (Courtesy West Licking Historical Society.)

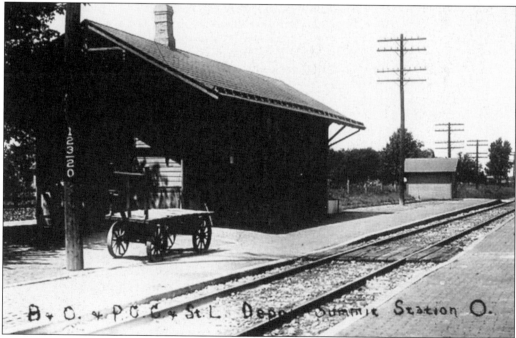

SUMMIT RAILROAD DEPOT. The multi-used railroad depot was located in the northeast corner of the Summit Road rail crossing in Summit Station, but today it is no longer standing. (Courtesy of West Licking Historical Society.)

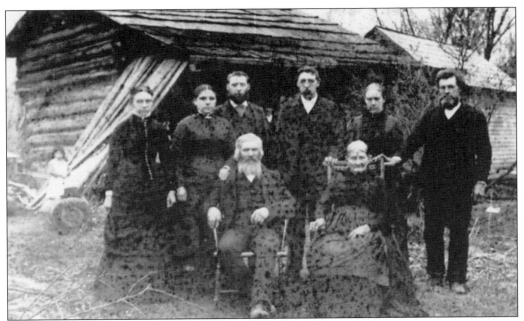

WILLIAM HENRY HARRISON COOPER. This photograph is of William Henry Harrison Cooper (1812–1894); his wife, Catherine Herron Cooper (1814–1892); and their family. Catherine was the daughter of John Herron, who came to Lima Township in 1805. The cabin was built around 1831. The little girl on the left of the photograph looks pensively at the camera. (Courtesy of Nelson "Bud" Cooper.)

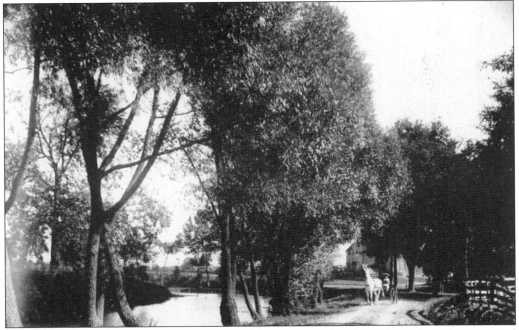

WILLOW BEND. This photograph was taken along Creek Road in the early 1900s and was printed from a glass plate negative taken by Eleanor Youmans, a Pataskala author of children's stories. It is a beautiful depiction of the South Fork of the Licking River and appears to be something out of a book. (Courtesy of West Licking Historical Society.)

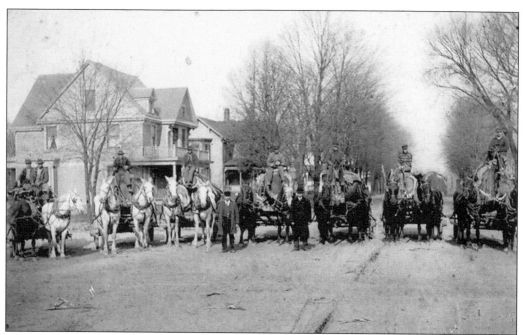

TEAMS WITH LOGS ON MAIN STREET PATASKALA. These teams of horses are hauling large logs on wagons through the residential area of town. They came from the nearby woods and are on their way to the sawmills in the southern end of Pataskala. The photograph was taken in the early 1900s. (Courtesy of West Licking Historical Society.)

PATASKALA STREET FAIR, 1909. The street fair parade in Pataskala, 1909, traversed Main Street just as it does today. In fact the viewing stand was in the exact location for the 2007 parade! The street fair is considered one of the year's most favorite and best celebrations. (Courtesy of West Licking Historical Society.)

OLD RINK. This winter scene shows the old skating rink in Pataskala. It was once located on Wood Street just south of the railroad. Sometime before 1922, it was moved west and north to a location on High Street. The old rink building is now used for storage. (Courtesy of West Licking Historical Society.)

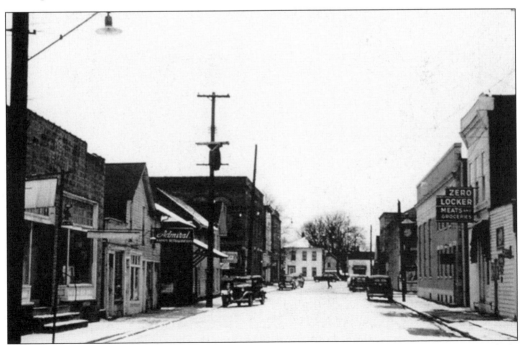

EAST DEPOT LOOKING WEST. There was not much traffic on East Depot Street in Pataskala when this photograph was taken in the 1920s. But then residents could buy meat and groceries at the Zero Locker. (Courtesy of West Licking Historical Society.)

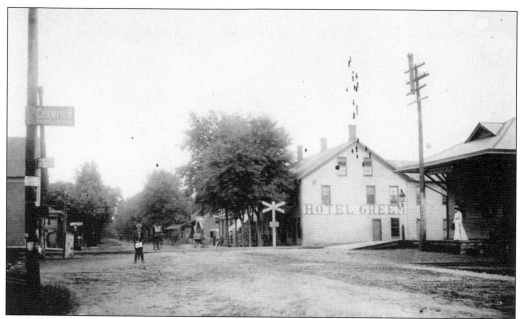

GREEN HOTEL, 1900. Built in the 1850s, this old hotel located next to the train tracks is the oldest structure in downtown Pataskala. Rooms were available for rent and were usually full of salesmen and others who would come by train. This building is still standing and is occupied by local businesses. The lady in the long dress stands on the platform of the Pataskala Railroad Depot. (Courtesy of West Licking Historical Society.)

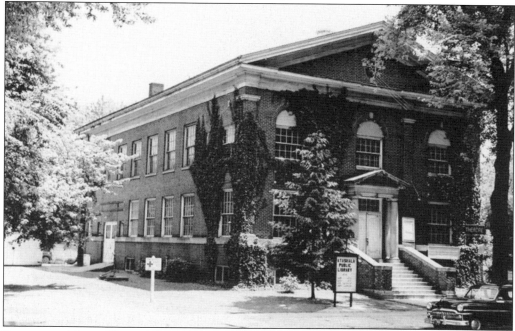

PATASKALA TOWN HALL. The Pataskala Town Hall, used for the town's business meetings until 2000, was built in 1916 on the site of the old high school on Main Street. The first Pataskala Public Library was founded in 1937 and was located in the building. It is now home to the Pataskala Police Department. (Courtesy of West Licking Historical Society.)

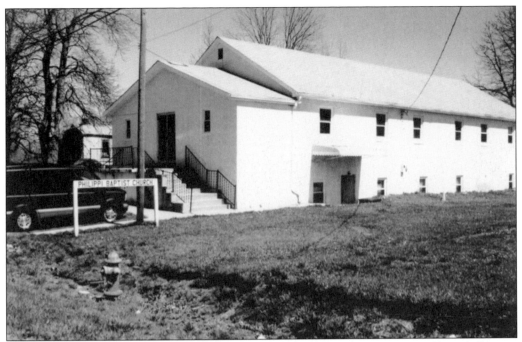

PHILLIPPI BAPTIST CHURCH. The Phillippi Baptist Church is located in Fursville, now known as the Blanche Addition, in the former Lima Township. Lima Township is now a part of the city of Pataskala. (Courtesy of West Licking Historical Society.)

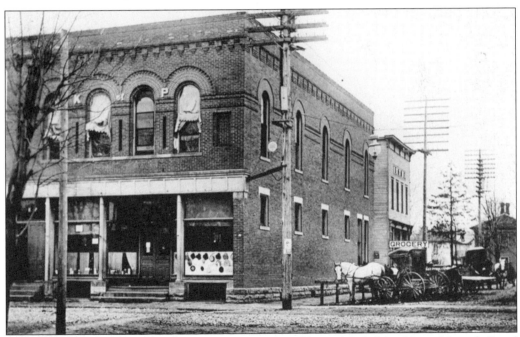

BAIRD BUILDING. When the original 1879 Baird Building of Col. John H. and Joseph Baird was destroyed by fire in 1898, they replaced it with this one. Built in 1898, on the corner of South Main and West Depot Streets in Pataskala, it housed the Knights of Pathias hall on the top floor.

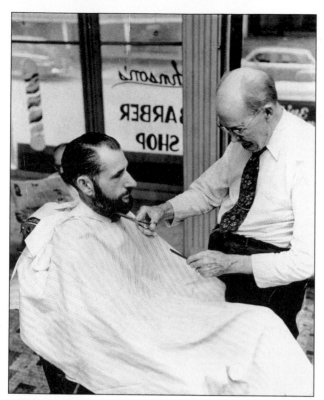

HAIRCUT. Barber Frank Johnson is trimming the beard of Hartman Ramsey, a local grocer, for the Pataskala centennial celebration in 1951.

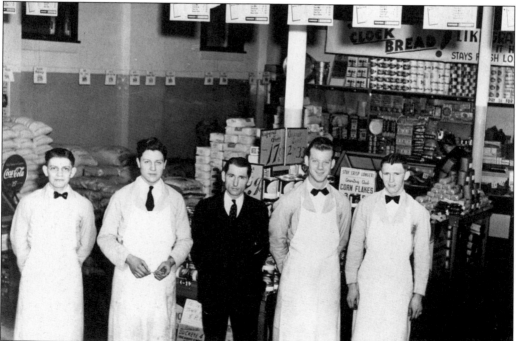

RAMSEY'S MARKET. The store clerks and owner are, from left to right, Stewart Wilson, John Smith, Hartman Ramsey, Bob Davis, and Joe Fraker. This was taken at a time when one could buy a can of grapefruit juice for 17¢ or two cans of orange juice for just 33¢!

OUTVILLE GIRLS' DRILL TEAM. The Outville girls' drill team is seen here around 1901. The girls pictured from left to right are Blanche Legg Rickly, Ella Jones, Florence Legg Prior, Louise Rugg Smith, Edna Jones, Lettie Cunningham Deeds, Merle Beecher, and Jessie Lucas. The young man's name is not known. (Courtesy of West Licking Historical Society.)

OUTVILLE BOYS' DRILL TEAM. In 1901, Outville had its own boys' drill team, too. It appears these young men decided to line up by height in front of the beautifully decorated screen. (Courtesy of West Licking Historical Society.)

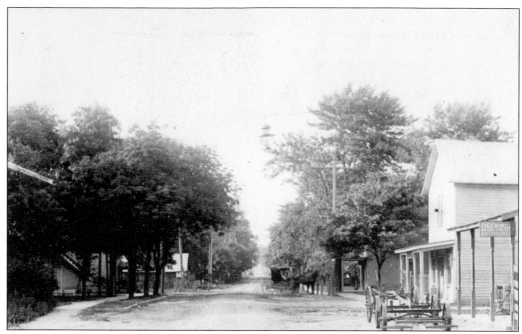

MAIN STREET IN OUTVILLE. Outville was a quiet, quaint little village in Harrison Township when this photograph was taken in 1912. What appear to be farm equipment and a push lawn mower sit in front of the Deering Machinery store. (Courtesy of West Licking Historical Society.)

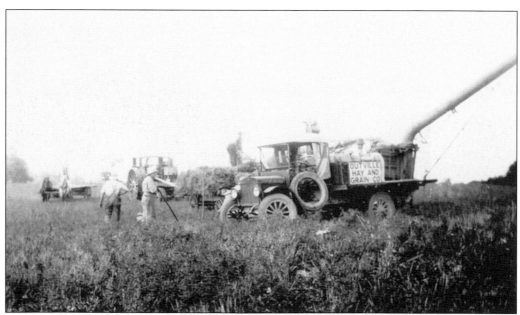

HAY AND GRAIN THRESHING. These farmers are threshing hay on York Street in Harrison Township in the 1920s. The truck in use was from the Outville Hay and Grain Company, a popular feed mill in Outville. (Courtesy of West Licking Historical Society.)

OUTVILLE PRESBYTERIAN CHURCH. This photograph of the Outville Presbyterian Church was taken in 1909, when it was located on the southwest corner at the intersection of the present Blacks and Outville Roads. The church was built around 1880 and has been moved to a new location. It is still in use today. (Courtesy of West Licking Historical Society.)

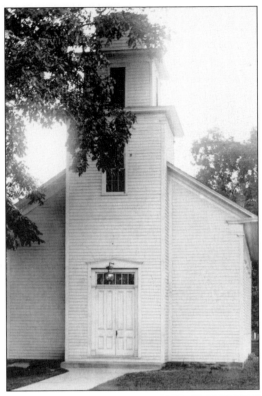

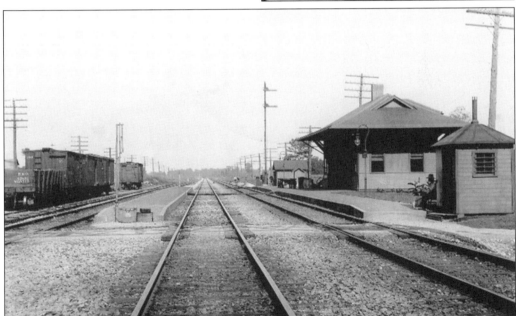

OUTVILLE DEPOT. The Outville Depot stood at the southeast corner of the Outville Road crossing until 1963, when it was moved to a local farm. It was later moved to the Harrison Township Complex in 1993, and in 2005, the building was restored to its original appearance and will become a transportation museum. The watchman can be seen sitting beside his shanty. (Courtesy of West Licking Historical Society.)

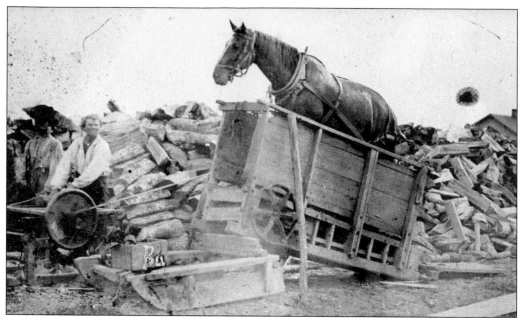

HORSE-POWERED TREADMILL. Pictured is Leverett Butler, who was born in Massachusetts in 1793 and known for his bravery, hunting skills, and general knowledge of the territory. In his later years he lived on what is now known as Watkins Road in Harrison Township. This photograph was taken in 1856. His horse is shown powering a treadmill to cut wood for an old wood-powered train that operated in and out of Pataskala.

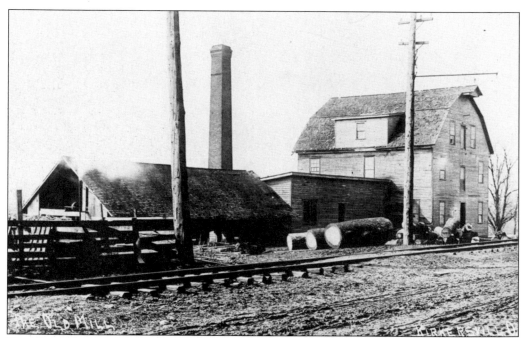

THE OLD MILL. Sawmills were built close to railroads whenever possible. The freshly sawn logs sit in the yard of the Old Mill in Kirkersville.

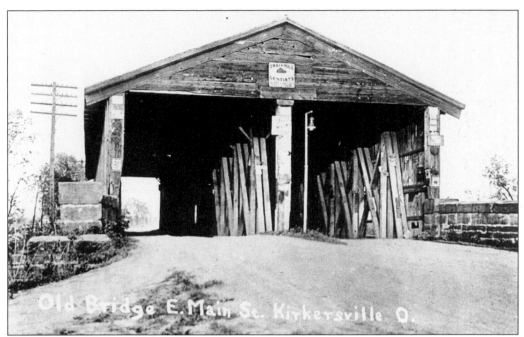

STURDY SPAN. This unusual two-lane divided covered bridge on East Main Street in Kirkersville carried traffic along the old National Road before it was torn down. Advertising posters are visible on the span, including one for Shai and Mill dentists.

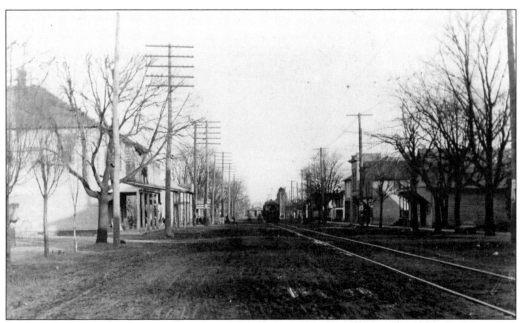

LOOKING EAST IN KIRKERSVILLE. On March 19, 1905, a devastating fire broke out about midnight and destroyed the business section of this village, including the George W. Frush building; Finkbone and Roibey buildings; H. H. Simmons buildings; J. T. Harris general store and farm implements; George W. Saviers general store; F. A. Rickley's barbershop; and Dr. J. W. Reelhorn's dentist office. The Stage Hotel was also leveled by the blaze.

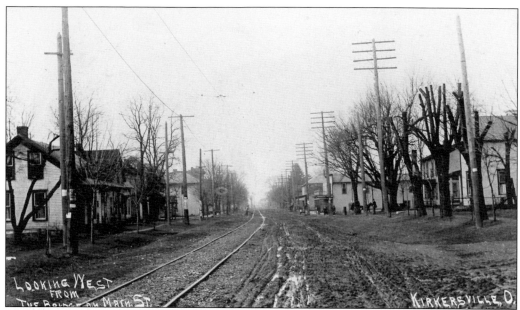

LOOKING WEST FROM THE BRIDGE ON MAIN STREET. The interurban tracks ran through Kirkersville alongside the muddy dirt road with wagon ruts. The photograph must have been taken in the wintertime since all the trees were bare of leaves.

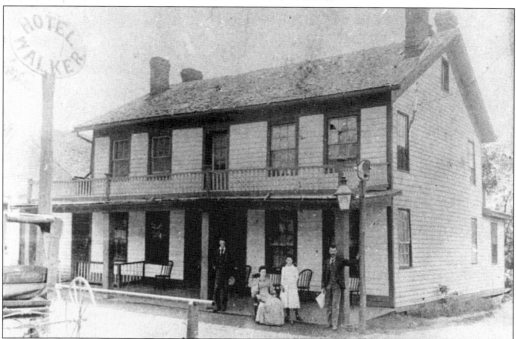

HOTEL WALKER. In the late 1800s, all small villages had at least one hotel. The Hotel Walker was located in Kirkersville. It is not known who stayed here, but Gen. William T Sherman was once quoted, "Kirkersville, I've been there many a time." In fact many great men came from within a 20-mile radius of the town: generals William T. Sherman, Phil Sheridan, William S. Rosecrans, Irvin McDowell, Charles Griffin, Charles R. Woods, Benjamin W. Brice, and Justice William Woods.

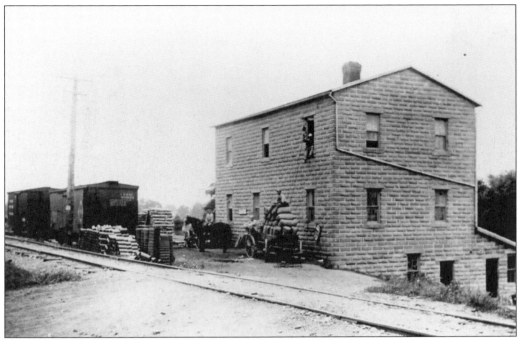

MILL LOCATED IN KIRKERSVILLE. This has been identified as the "new" mill in Kirkersville. The sturdy stone structure must have taken the place of an old wooden one. The man sitting in the window of the top floor seems to be lowering bags of something. Could it have been flour?

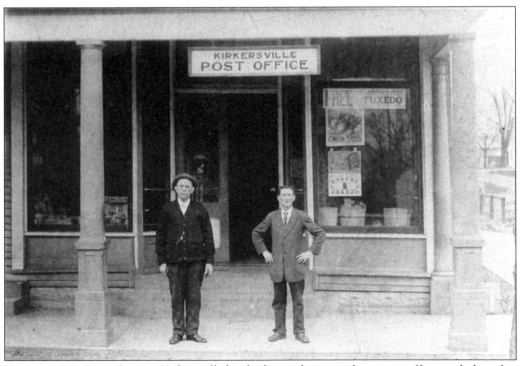

KIRKERSVILLE POST OFFICE. Kirkersville has had many locations for its post office, including this one. Here one could pick up their tuxedo, onion seeds, and cornstarch along with the mail.

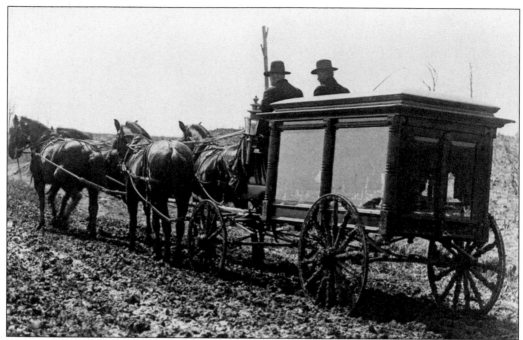

HORSE-DRAWN HEARSE. On the way to the Kirkersville Cemetery, William Larimore and an unidentified man ride atop a horse-drawn hearse as the horses trod through the muddy field to reach the grave site. The hearse was beautifully constructed with glass sides and carriage lights.

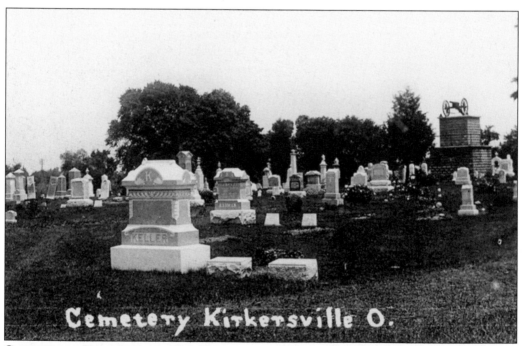

Cemetery Kirkersville O.

CEMETERY AT KIRKERSVILLE. The old cemetery at Kirkersville still sits just outside of town on a quiet country road. The monument in the back on the right of the photograph with the cannon on top was dedicated on October 24, 1908, and is known as the Soldiers Monument.

OHIO ELECTRIC WORK CAR AT ETNA. These two gentlemen "ride the rails" in car No. 725 through Etna in the early 1900s.

DOUBLE INTERURBAN CAR. At 62 feet, interurban car No. 150, built by the Barney and Smith Company of Dayton, was the longest interurban car ever built. It looks to be headed to either Newark or Zanesville. This photograph was taken in Etna about 1909.

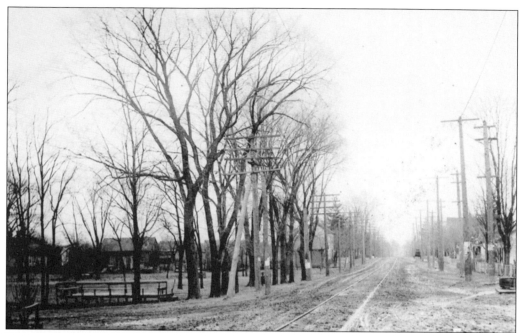

PUBLIC SQUARE IN ETNA. When Etna was laid out in 1833, this land was set aside for what villagers hoped would be the location of the new Licking County courthouse. It was known as the Etna Commons for many years, but its use as a courthouse location was obviously never realized. It has since been landscaped, a gazebo was added, and it is called Highpoint Park.

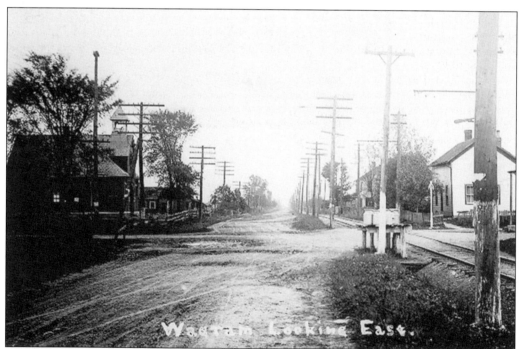

WAGRAM, 1909. This is the old National Road in Wagram, looking east, about 1909. The interurban tracks can be seen on the right of the photograph running alongside the dirt road.

Eight

UNION AND LICKING TOWNSHIPS

Philip Sutton, Job Rathbone, and John and George Gillespie arrived in Licking Township in 1801. That same year the township was organized as one of Fairfield County. In 1808, the township was split to create Union Township on the west and Bowling Green on the east. The size of the township was reduced even more when Newark on the north was organized in 1810, and Franklin on the east in 1812. Early settlements included Atherton (also known as National Road), Bruno (now known as Avondale), Fleatown (known also as Van Buren), Hog Run, Jackson (now known as Jacksontown), Locust Grove, Lloyd Corners (also known as Lloyd's Shop and Mechanicsburg), Melgren, Moscow (known also as Green) Reservoir, and South Newark.

Licking Township, the largest township in the county, was known to be rich in antiquarian relics. There are tales of axes, hatchets, pipes and hammers of stone, and broken pottery being found during the first settlements. The first settlers are thought to be John VanBuskirk, Benjamin Murphy, and J. Wayman in 1800. The township was organized in 1808. Early settlements included Benjamin, Kylesburg, and Union Station.

PURE OIL REFINERY. While most historians associate the name of the city of Heath with the Pure Oil Refinery, few provide knowledge of the man whose name the city bears. Fletcher Heath had a brilliant financial mind, devoted most of his life to the study and practice of banking and finance, and served as a leader in the organization and management of many large corporations. (Courtesy of Tim Bubb.)

SOUTHGATE SHOPPING CENTER. Heath first became a village in 1951 and was incorporated as a city in 1965, when the population topped 6,000. The Southgate Shopping Center on Hebron Road is shown in the photograph taken around the late 1950s. This was just the beginning of the building boom for Heath and its retail and commercial businesses. (Courtesy of Tim Bubb.)

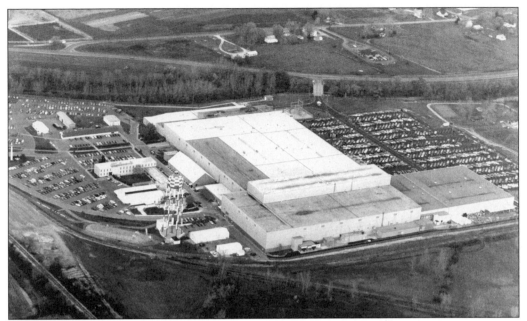

NEWARK AIR FORCE BASE. The U.S. Air Force Calibration Program was initiated in January 1952. By 1962, the primary calibration labs and the Air Force Measurement Standards Laboratories were moved to Heath and the facility was named Newark Air Force Station. It was renamed Newark Air Force Base in 1987. The base was closed in October 1996. After closure, the missile and aircraft repair workloads were privatized. (Courtesy of Clarence Santos.)

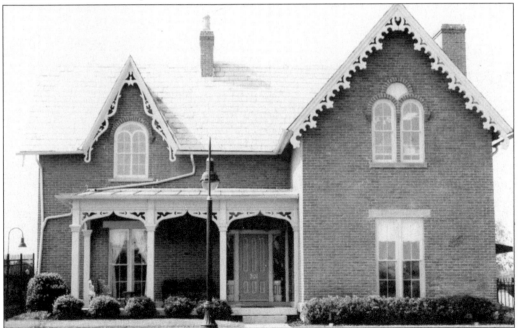

DAVIS-SHAI HOUSE. The Davis-Shai House is a Gothic Revival home whose architectural style is attributed locally to Andrew Jackson Downing, a nationally prominent landscape architect whose book *Cottage Residences* was widely distributed from the 1840s to the 1880s. The house has weathered 146 winters and has become the city of Heath's cultural and historical showplace.

DAWES ARBORETUM. Beman and Bertie Dawes founded the arboretum in 1929. It has over 1,700 acres of plant collections, gardens, and natural areas. Many prominent people have planted trees there, including Gen. Charles G. Dawes, brother of Beman and former vice president under President Coolidge. The Daweswood House contains a collection of ceremonial shovels used in these plantings. (Courtesy of Tim Bubb.)

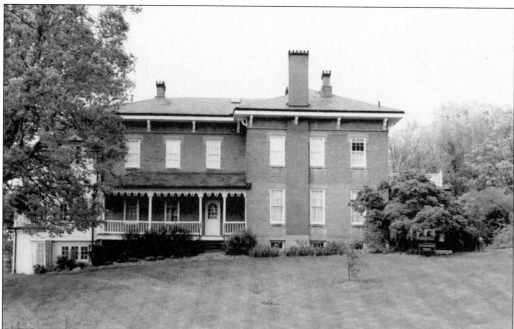

DAWESWOOD HOUSE. Once the Dawes family's country home, the Daweswood House Museum contains a collection of 19th- and 20th-century antiques, collectibles, and photographs that reflect the lifestyle and collecting interests of the founding family. The gardens of Bertie Dawes have also been restored.

94

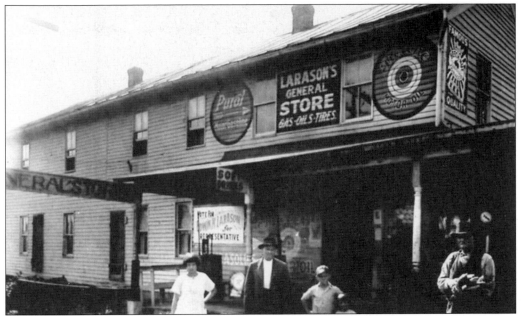

LARASON'S GENERAL STORE. The general store sat at the corner of the old National Road and State Route 13 in Jacksontown. The Larason family operated this general store for many years until about 1940. Edwin Larason, the store's owner, is pictured second from left. With him are his daughter Mildred Larason Patterson; his son Donald Larason; daughter Faith Larason Felumlee; and Benny Brownfield.

LARASON CHILDREN. This photograph was taken in front of Jacksontown School. Pictured from left to right are Mildred, Virginia, Don, Faith, Ray, and Harvey Larason. All the children helped in the store. It was a typical general store with nails in kegs, brown and white sugar in barrels, material, and jewelry.

CLASS OF 1935–1936 JACKSONTOWN SCHOOL. Pictured are members of the senior class. From left to right are (first row) Dale Jones, Evelyn Hoskinson, Helen Tunison (teacher), Helen Jones, Alice Baker, Bernice Hoskinson, Gladys Cooperider, and Jim Lamp; (second row) Dick Johnson, Joe Foulk, Wilbur Satterfield, Ray Adamson, Orville Dusthimer, and Jesse Wollard; (third row) Wilbur Swartz, Bob Davis, Don Larason, and Bob Griffith.

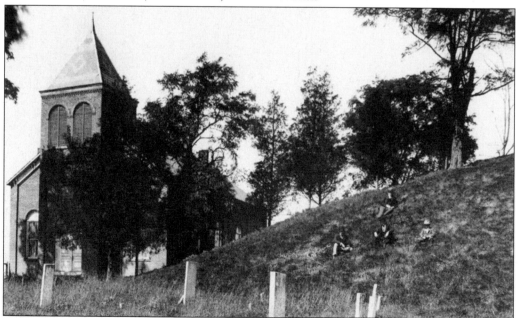

FAIRMOUNT PRESBYTERIAN CHURCH. Since 1883, the Fairmount Presbyterian Church has occupied a beautiful elevation, in full view of the National Road in the vicinity of a large mound and numerous other works of the Mound Builders. Fairmount Mound is approximately 15 feet high with a diameter of 80 feet at the base. Identified as a lookout mound, it was excavated but contained nothing of historical value.

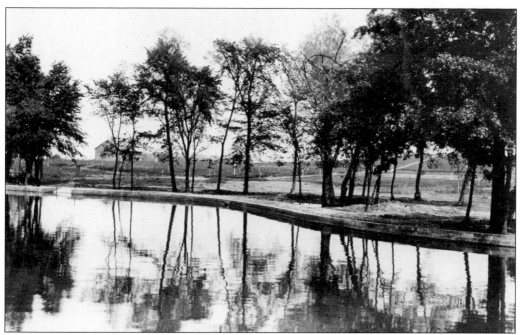

HARBOR HILLS. Harry D. Freeman and the Lake Development Company first developed Harbor Hills in 1922, when it was a waterside farm. It has grown into a beautiful summer colony of homes with roads, parks, docks, and beaches. Instead of summer cottages, as the lots were sold, the people built year-round ones and came and stayed throughout the winter.

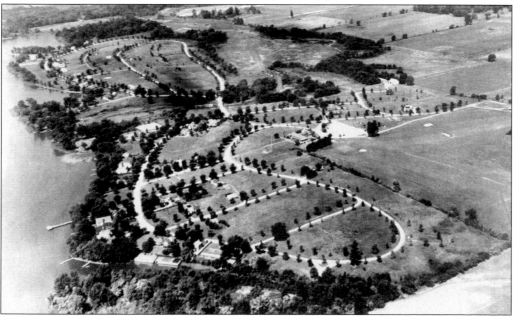

ARIEL VIEW OF HARBOR HILLS. Freeman used New England as a model for the village. It has winding roads, the clubhouse on the hill, the village green with houses on either side running to the beach, and looks very much like Sturbridge Village, Massachusetts. The roads, named Cornell, Dartmouth, and Amherst, bear this out. Harbor Hills once had a post office established on March 31, 1927, but closed in April 1943.

HARBOR HILLS FARM. The barn pictured was moved to the polo fields where the Harbor Hills Women's Club had a refreshment stand. Here the ladies sold hot dogs, snacks, soft drinks, candy, and coffee. One of the polo players was Ann Gilbert, the only woman polo player in the Midwest. Pictured in the *Women's Club History* book, she is identified with the caption, "She played with the boys."

HARBOR HILLS POLO. Polo was first played locally by a group of Hebron businessmen and was known as the Hebron Polo Club. They started with little more than farm horses and a rough idea of the game "hit the ball as hard and as often as possible." Pictured from left to right are Ralph C. Barnett, Alan Holman, L. W. Fisher, Walter Shapter Jr., Ralph Fitch, H. Allen Chapman, and E. O. Myer.

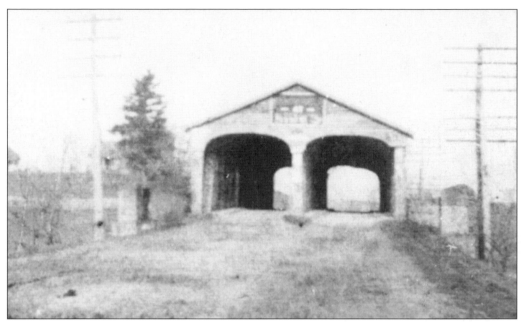

MOSCOW BRIDGE, HEBRON. Moscow became a thriving village on the old National Road (U.S. 40), two miles east of Hebron, after Daniel and William Green erected a mill on the south fork of the Licking River in 1830. The bridge was a double bridge with a partition in the middle to separate eastbound and westbound traffic. It was the last wooden covered bridge to be removed on the entire road from Indianapolis to Baltimore.

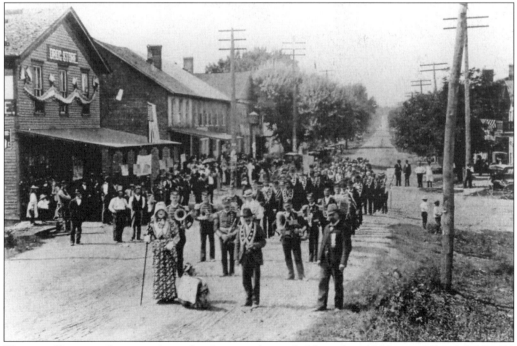

HEBRON PARADE. It is not clear why this parade was held on the old National Road (U.S. 40) through Hebron, but a large crowd turned out around 1885 to see the six- or seven-member band and elegantly attired men in uniform led by an old lady march east from Canal Bridge.

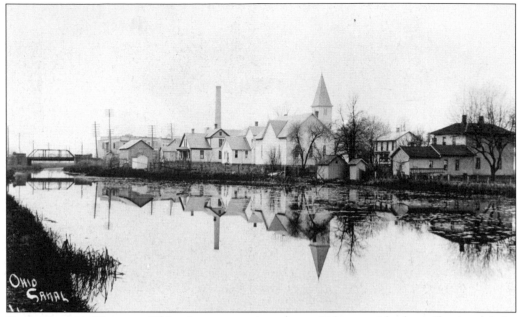

OHIO CANAL, HEBRON. This picturesque view shows Hebron, with the reflection of the village in the Old Ohio Canal. Founded in 1827 by John Smith, it became an important link on the Ohio Canal System. This sometimes raucous canal town, with its tanneries, sawmills, warehouses, and distilleries, was for a time a busy marketplace and was known to pioneers of the day as a center of agriculture and industry.

ORIGINAL HEBRON METHODIST CHURCH. David Lewis started the Methodist Church in Licking County. The first sermon given in the Northwest Territory was delivered at George Well's cabin in 1802 in Luray. Shown is the 1840s original Hebron Methodist Church in 1903, with the Sunday school superintendent leaning on the fence.

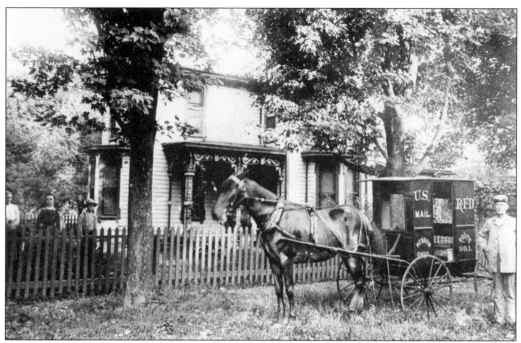

U.S. MAIL, HEBRON. Standing in front of the Millhouse home built in the late 1800s in Hebron is Townsend Millhouse. He was the first rural mailman in Hebron, delivering the mail by horse and wagon.

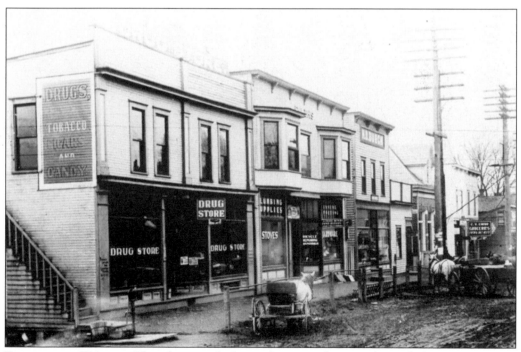

DOWNTOWN HEBRON. This photograph shows the stores that were located along Main Street when the road was mostly mud. Among them were the Hebron Drug Store, a hardware store, and two groceries, including Burch's.

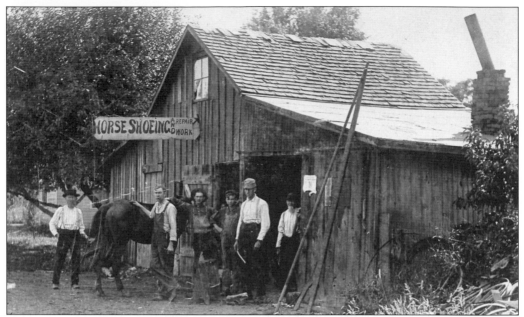

HORSESHOEING BUSINESS, HEBRON. In 1910, Floyd "Flossie" Cooperider was a well-known blacksmith. The photograph shows the horseshoe stable where Cooperider worked. In the 1930s, he shod many horses that were ridden by the Harbor Hills Polo pony team. It has been said that the metallic content of the tub water where the hot horseshoes were cooled was a great cure for poison ivy.

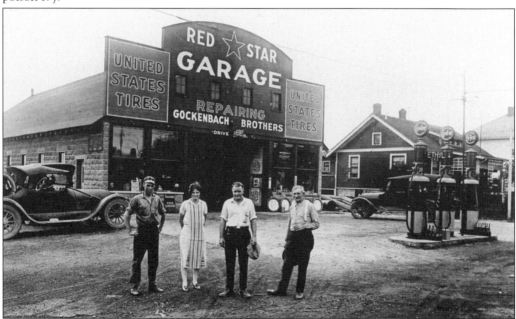

RED STAR GARAGE, HEBRON. Ed and Art Gockenbach built the Red Star Garage in the early 1900s. It was known as the Red Star Garage because it serviced the buses on the Red Star Line. One could drive their car into the Gockenbach Brothers garage for repair or servicing, get a new set of United States Tires, buy gas from the pumps out front (even high test), or order a ham and cheese sandwich.

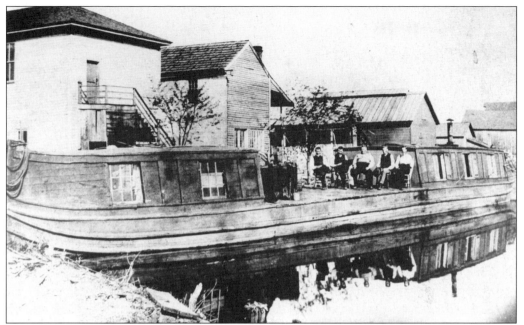

CANAL BOAT, HEBRON. This canal boat is an example of one of the boats that floated on the waters of the Ohio Canal. One of the first canal boats that were built in the county was christened *The Lady Jane.* She met a terrible fate when it was discovered the boat was too wide for the lock. It returned to Hebron and spent all its days in the Hebron Basin.

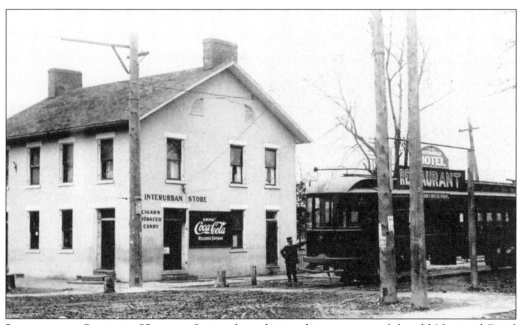

INTERURBAN STATION, HEBRON. Located on the northwest corner of the old National Road (U.S. 40) and Ohio State Route 79, the building was erected in 1834 and was a home for the David Shearer family. With the coming of the traction trains, it became the station in 1901. The cars swung around the building, getting in the proper position to go to either Newark, Buckeye Lake, or Columbus.

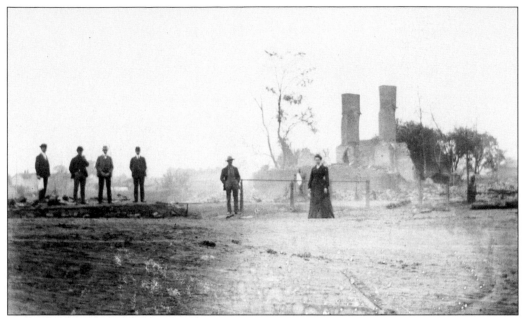

THE 1901 FIRE, HEBRON. The completion of the National Trail brought on another era, during the early 1800s, in which passed thousands of prairie schooners, Conestoga wagons, stages, and horse-backed riders bound for the fabled west. At the beginning of the 20th century, a disastrous fire destroyed most of the business district, bankrupting many villagers. Shown are the devastation, the somberness, and the hopelessness on faces.

CUMMINS ICE CREAM. In 1934, Earl Cummins and Guy Kirk began making ice cream by making their own mix, cranking the freezers by hand, and transferring the five-gallon cans to the Hebron Ice House for storage. Earl married Dorothy Hamilton and Guy decided to discontinue the business. The Cummins family operated the business until they retired in 1977. Jensen Gartner enjoys an ice-cream cone at the same location now known as Clay's Café.

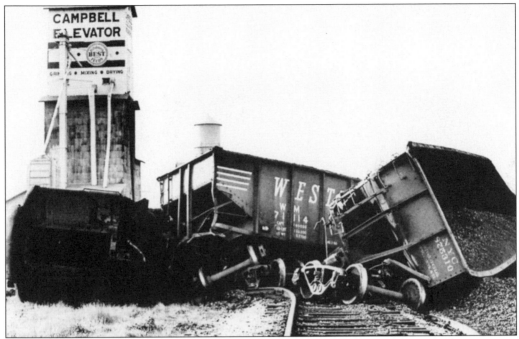

TRAIN WRECK, HEBRON. A jumble of coal cars is shown after a train accident that occurred in October 1961 near the old Campbell Elevators. Campbell's was also known as the feed mill.

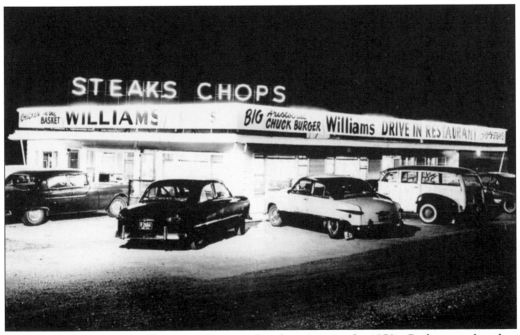

WILLIAMS RESTAURANT, HEBRON. This was the place to go in the 1950s. Carhops took orders and brought the food on a tray right to the car window. They served steaks, burgers, and chops, but their specialty was chicken and noodles. Take note of the 1949 Studebaker Convertible on the far right.

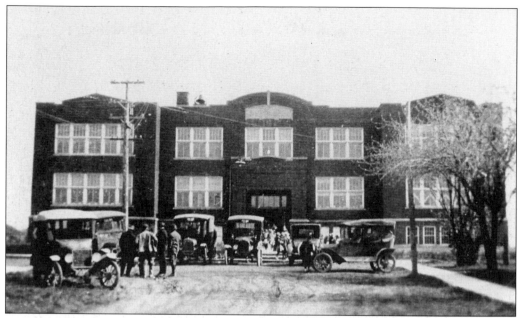

HEBRON SCHOOL. The Hebron School was built in 1914 as a school for grades 1 through 12. In 1936, extensive remodeling was done and a large gymnasium was added. At that time it was the largest of all the county schools. Lined up in front of the school are school buses waiting for the children. The last class to graduate from Hebron School was in 1959, when it consolidated to become the Lakewood school district.

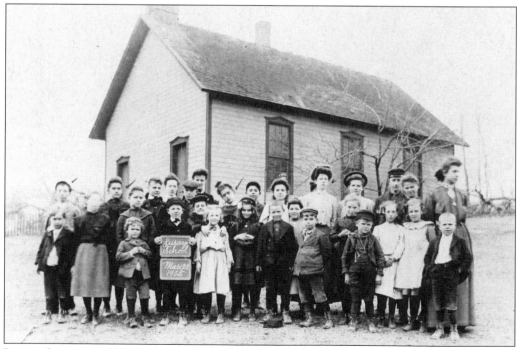

LURAY SCHOOL, 1905. Luray is a small village located between Hebron and Kirkersville at the corner of Ohio State Route 37 and U.S. Route 40. This photograph shows the class of 1905 at the Luray School. There is no longer a school in Luray.

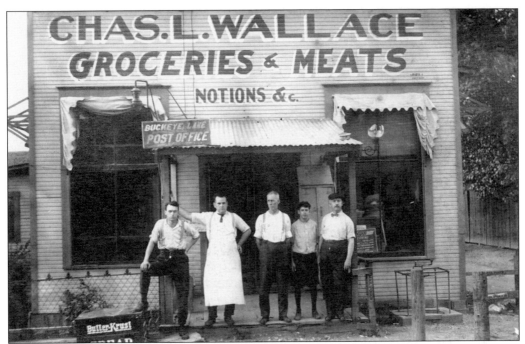

BUCKEYE LAKE POST OFFICE. The first post office in Buckeye Lake was located in Charles L. Wallace Groceries and Meats.

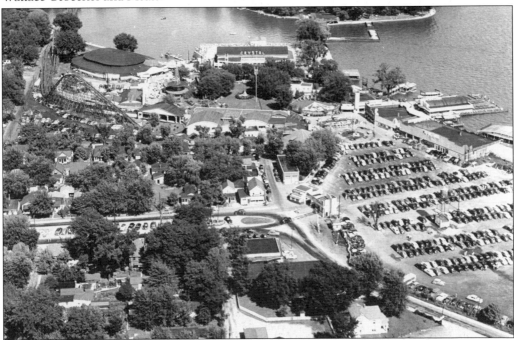

BUCKEYE LAKE PARK. By the second decade of the 20th century, Buckeye Lake boasted an amusement park as well as a number of hotels, restaurants, and other businesses catering to tourists. The Crystal Ballroom attracted numerous famous performers, such as Guy Lombardo, Count Basie, Glen Miller, Benny Goodman, Louis Armstrong, and Duke Ellington. Grand entertainments continued throughout the 1940s, attracting as many as 50,000 people each day.

BUCKEYE LAKE YACHT CLUB. The Buckeye Lake Yacht Club celebrated its 100th anniversary in 2006. The founding of the club took place at Leachman's Restaurant in Columbus on April 24, 1906. Located on Watkins Island, the Buckeye Lake Yacht Club is the only island yacht club in America.

CRANBERRY POINT. The area of Cranberry Point at Buckeye Lake was once known as Blue Goose. It was part of the Bounds family farm, and cows from the farm would wander down to the lake. But times have changed, and today it is the site of beautiful condominiums with lakefront views.

Nine

FRANKLIN, HOPEWELL, AND BOWLING GREEN TOWNSHIPS

In the late 1800s, Franklin Township was known as a Mound Builder's paradise. Among them was Tippitt mound, said to have contained two well-preserved crania in connection with quite a number of other human skeletons. The township was composed entirely of U.S. military lands. These army lands were given as payment to officers and soldiers of the Revolution by the government. The first settlers were George Ernst and John and Jacob Switzer in 1805. The township was organized in 1812. Early settlements included Fairfield, Flint Ridge, and Linnville.

First settled about 1805–1806, William Hull, Isaac Farmer, Samuel Pollock, and others were among the first to arrive in Hopewell Township. The township was organized in 1814. This township is best known for the Flint Ridge area. Early settlements were Gratiot, Hopewell, and Little Claylick.

The first settlement of Bowling Green Township was made in 1802. Michael Thorn, Frederick Myers, and Henry Neff came from western Virginia and settled about a mile south of Linnville in what was then called Little Bowling Green. The township was organized in 1808. Some early settlements included Amsterdam, Brownsville, Linville, Little Bowling Green, and Mount Hope.

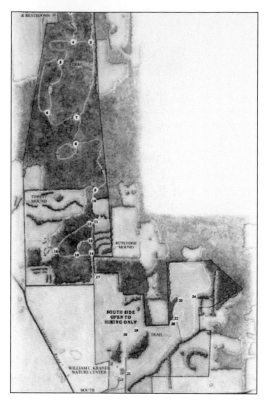

TAFT RESERVE. Franklin Township abounded in works erected by the Mound Builders. The well-known Tippitt mound, with a base diameter of 75 feet and 21 feet high, is located on Taft Reserve. Today the 425-acre reserve contains six-plus miles of horseback riding and hiking trails through woodland and meadow habitats. The area is noted for its abundance of spring wildflowers, owl, deer, wild turkey, and coyote.

RUTLEDGE MOUND. The Rutledge mound is also located on Taft Reserve. The double-headed frog is a fine example of Hopewell skill and artistry. Native copper from the Lake Superior region was hammered into a thin sheet and then cut with flint into the desired shape. The frog was found during an excavation made in 1930 by Jesse Walker and John Laugman. The frog shown is a replica made by David Phillips.

110

OIL WELL. The oil well pictured was located on Fairview Road on the Stevens property. Many family members gathered to have their photograph taken around 1915. Irma Stevens, approximately age 9, is pictured on the very top. (Courtesy of David Phillips.)

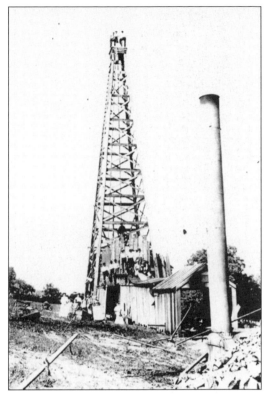

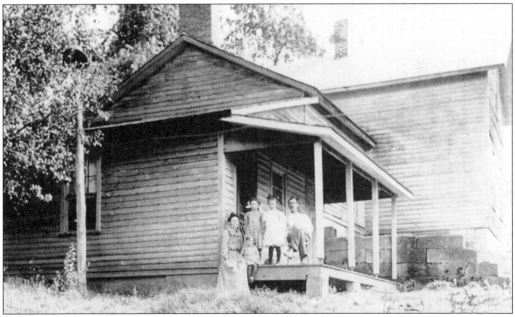

LOGAN STEVENS HOMESTEAD, C. 1909. Pictured are Logan Stevens, Bertha Bixler Stevens, and their children Irma, Alma, and Hugh Stevens. The family had a large garden and asparagus patch. They also had two workhorses named Dick and Jane. A springhouse was located down the hill from the main house and was used to keep milk and other perishables cold. (Courtesy of David Phillips.)

FLINT RIDGE QUARRY PIT. Tribes came from as far away as Minnesota and Florida to mine flint for tools and weapons. The American Indians bartered flint for metals, shells, and other materials. According to legend, the operations were not always peaceful, for tribes fought for control of the mines. This continued for many moons until the Great Spirit called the chiefs together in a peace council on the high ridge.

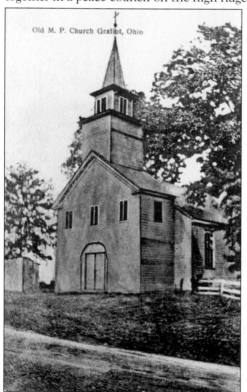

Old M. P. Church Gratiot, Ohio

OLD M. P. CHURCH, GRATIOT. In 1843, trustees of the Methodist Protestant Society purchased property atop a hill. Lot Davis and Benjamin Hull founded the church, valued at $1,000. Contributions from members and other residents of the village and surrounding area paid for the building. Dedication was held in 1843. Later $100 was raised for a bell that was used until it cracked in 1877. The Old M. P. Church was razed on July 4, 1905.

EAGLE NEST MONUMENT. Located a mile west of Brownsville, the large granite rock, marking the highest elevation on the National Road in Ohio, holds an inscription commemorating the concrete paving of the National Road from Zanesville to Hebron from 1914 to 1916. Also chiseled in the granite are renderings of a Conestoga wagon, an automobile, and the distances to Columbus (32 miles) and Cumberland, Maryland (220 miles).

FLOUR MILL, BROWNSVILLE. This gristmill still sits on the north side of the National Road in Brownsville. Today it is an antique shop.

BROWNSVILLE SCHOOL. The National Trail School House Inn was formerly known as the Brownsville School. Built in 1900, the schoolhouse served grades 1 through 12 until 1934, and housed grades 1 through 8 until its closure in 1948. This handsome building has been graciously transformed into a spacious and delightful country bed-and-breakfast but still retains the spirit from school days of a century ago.

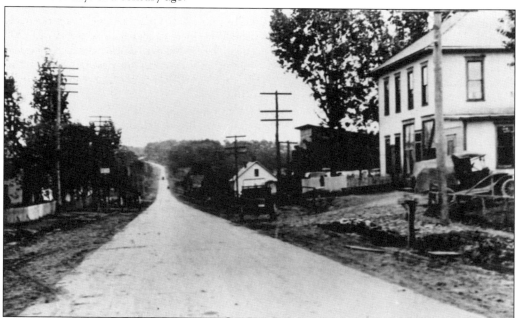

NATIONAL ROAD. The National Road celebrated its 200th anniversary of the signing of legislation authorizing the National Road's construction in 2006. In 1806, Pres. Thomas Jefferson signed the bill for the nation's first federally funded interstate highway, which opened the nation to the west and served as a corridor for the movement of people and goods. New towns created along the road became known as "pike towns."

Ten

FACES, PLACES, AND EVENTS OF LICKING COUNTY

Licking County celebrates its bicentennial in 2008. The past 200 years have brought unimaginable changes. From the first child born in 1799, the population has risen from a few settlers to 154,806 in 2005. The county has seen the youngest soldier ever to bear arms in a military conflict, a woman run for president, numerous state congressmen and a president of a foreign country elected, two Congressional Medal of Honor recipients, an Olympian silver medal winner, an ordained Catholic bishop, and a U.S. Supreme Court justice appointed. Presidents John Q. Adams, Benjamin Harrison, Abraham Lincoln, Ulysses S. Grant, Warren Gamaliel Harding, Rutherford B. Hayes, Theodore Roosevelt, and Gov. Bill Clinton visited the county before becoming president. The county was the first in the nation to have a female bank cashier and female bank president, to give a lie detector test, to use two-way radios, and the only to build an interurban tunnel in Ohio. The first shovel of dirt for the Ohio-Erie Canal was taken on July 4, 1825, in Heath. The first Red Cross ambulance in World War I was made by W. S. Wright of the Jewett Car Works in Newark and delivered to France. The first museum in the United States dedicated entirely to prehistoric man is located in Licking County. The first shot of the Civil War was fired at the men under command of Newark native Charles R Woods. Newark was the first city in the nation to observe Flag Day in 1892. At one time Licking County has been home to the largest stove manufacturer in the world, the largest geometric earthworks in the world, the largest maker of bottles in the world, the largest gas pumping station, the largest wool-producing center in the world, the largest basket in the world, and the longest "bridge" in Ohio. Licking County has gone from prehistoric man using flint for weapons and tools to hosting an industry that repairs guidance and navigation systems for the military and manufacturing for the Minuteman II guidance replacement program. The county has grown from a one-room schoolhouse to 10 school districts, 12 private schools, and even several institutions of higher learning with thousands of students. Today the county is proud of its many modern amenities, including its health systems, industries, shopping areas, and sporting and entertainment facilities. It is also proud of the historical buildings, rich farmland, and comfortable lifestyle of its people.

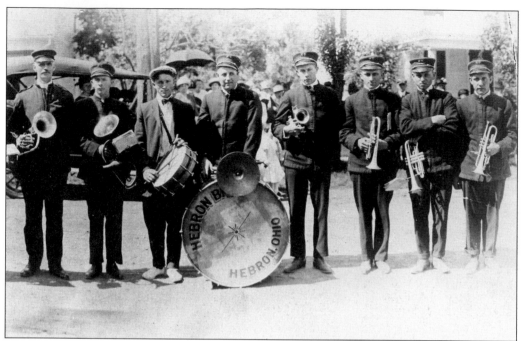

HEBRON BAND, 1900S. Music has always been an important part of life in Licking County. This small band from Hebron entertained at parades and social events in the late 1800s and early 1900s.

LAKEWOOD HIGH SCHOOL MARCHING BAND. The 100-plus-member band, known as the largest rock and roll band in Licking County, receives many requests to perform its popular upbeat music and dancing. It performed for the 211th Ohio National Guard Unit send-off prior to deployment to Iraq. Joshua Halter, Lakewood's first drum major, has been selected as Ohio State University's assistant drum major. (Courtesy of Angela Porter.)

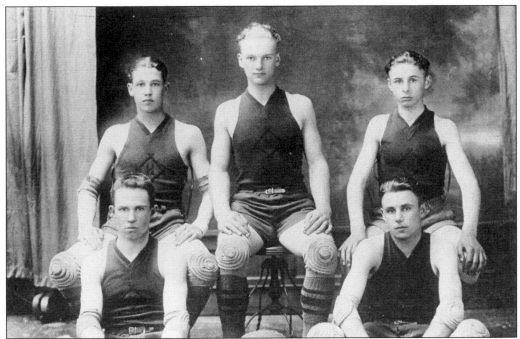

HEBRON BOYS' BASKETBALL, 1921–1922. Uniforms of the basketball players were much different than those of today. In the early 1920s, the Hebron boys' basketball team members wore knee and elbow pads for protection and athletic shoes that were popular during that time.

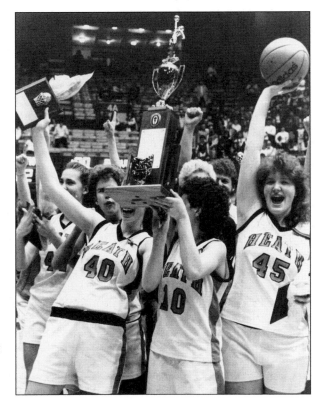

HEATH GIRLS BASKETBALL, 1991. Minutes after they swept to an easy victory in the finals of the Division III State High School Girls Basketball Championship game at St. John Arena in Columbus, the Heath High School Lady Bulldogs hoist high the well-deserved winning trophy. It was the first championship in any sport for that high school. (Courtesy of Chance Brockway Jr.)

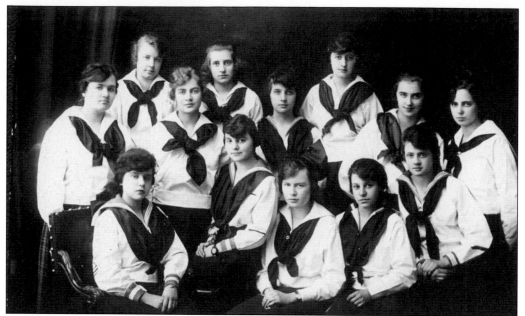

THE 20TH CENTURY CLUB. The members of the 20th Century Club in 1919 were, from left to right, (first row) Anna Haynes, Neva Hulshizer Hornby, Helen Norpell Price, Mildred Simpson Hite, and Laura Beggs; (second row) Mary Kibler Orr, Elizabeth Kebler McClellan, Marion Montgomery Dickinson, Margaret Bader Murphy, and Mary Windle; (third row) Hazel Colville Ankele, Dorothy Wilson Wright, and Louis Henderson. (Courtesy of 20th Century Club.)

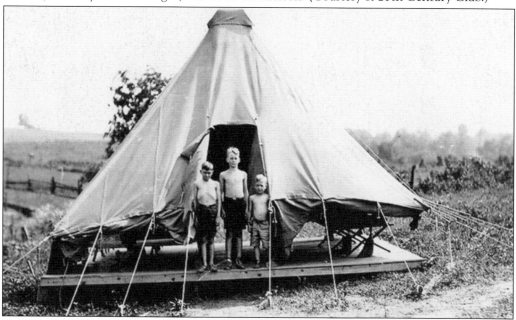

HEALTH CAMP. In 1923, the 20th Century Club joined Phi Sigma Chi fraternity and the local Kiwanis Club to sponsor the Holly Ball, an annual Christmas dance. Their efforts raised funds for what was known as the "health camp," a camp for children with tuberculosis contact. In 1937, a musical variety show was begun as a major money-making project. "The Flyer" continues today. (Courtesy of 20th Century Club.)

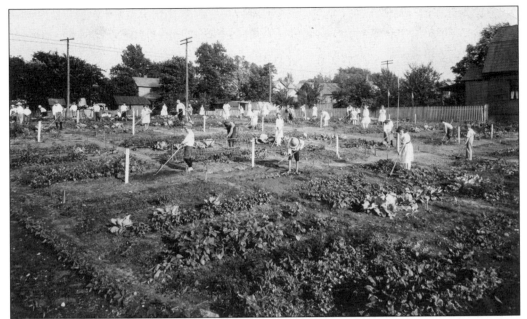

COMMUNITY GARDENS. During World War II and a few years following 1945, community gardens were very popular, like this well-cared-for one on Cedar Street. Many families had garden plots with children and parents working together to supply food for their tables. Gardening is still popular and considered the number one hobby in the country, but the dress mode of the ladies and children are vastly different today. (Courtesy of Tim Bubb.)

MASTER GARDENER JUNIOR GARDEN. The Licking County Master Gardeners have a Junior Garden program located at the county extension office. Children plant and maintain their own garden plots with vegetables and flowers. Programs teach the children about soil, composting, recycling, and beneficial insects, as well as the basics of gardening. Master Gardener Walt Hinger is shown dipping out "stone soup" in 2002.

NATIONAL ROAD. In Licking County the National Road starts in Gratiot, a pike town named for Brig. Gen. Charles Gratiot. The white markers like these are prevalent along U.S. Route 40. The other marker commemorates the 200th anniversary of the National Road. Other pike towns in Licking County include Brownsville, Amsterdam, Jacksontown, Hebron, Luray, Kirkersville, and Etna.

NATIONAL TRAIL RACEWAY. With speeds well over 200 miles per hour, the National Trail Raceway has seen the best racers from around the world race down the famous quarter-mile track. Clark Rader Sr. and sons Clark Jr. and Ben broke ground for the track in 1963. In 1972, they hosted the National Hot Rod Association Spring Nationals. Three years later the NHRA purchased the track from the Raders. (Courtesy of Chance Brockway Jr.)

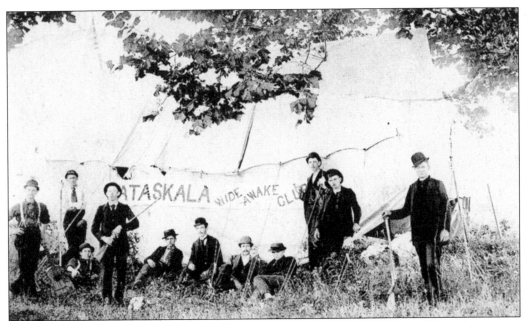

PATASKALA WIDE AWAKE CLUB. Wide Awake clubs were organized all over the country during the presidential campaign of 1860. The semi-military organization's determination was to "maintain with the sword," the result of the ballot. The clubs were particularly active during the Civil War but continued during political mass meetings in the following years. (Courtesy of West Licking Historical Society.)

MUSHROOM HUNTING IN LICKING COUNTY. One thing that has not changed in Licking County is the hunt for the elusive morel mushroom. Residents of the county today still enjoy an early spring walk in the woods to find one of the tastiest treats around. By the looks of the basket being held by this gentleman, his adventure was an outstanding success. The photograph is probably from the early 1900s.

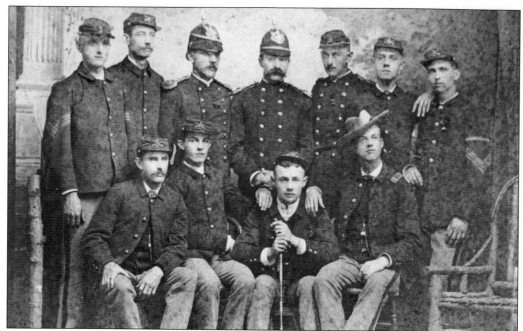

THE 17TH REGIMENT OHIO NATIONAL GUARD, 1892. In 1895, Company G, 17th Regiment was officered by Capt. Walter A. Irving; 1st Lt. Charles W. Miller; and 2nd Lt. Elmer Blizzard. Identified in the picture are Cary W. Montgomery (back row, third from left) and I. Milton Phillips (back row, fifth from left).

WORLD WAR II VETERANS. The first World War II casualties from Licking County were Ray Davis of Newark and Melvyn Horne of Croton, both killed at the attack on Pearl Harbor. These World War II veterans are, from left to right, (first row) Herb Fown, Gene Fields, Doug Galloway, Junior Steindam, and Paul Nixon; (second row) Jake Johnson, Woody Wood, Herb Beger, and Ralph Hecker. (Courtesy of West Licking Historical Society.)

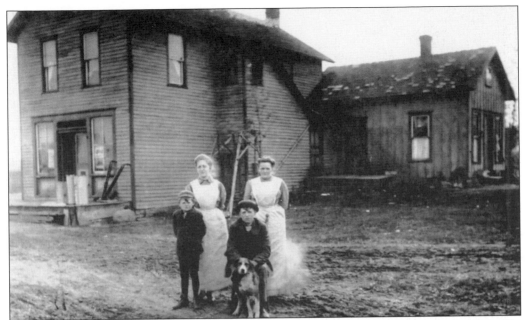

ASH. Ash Corners was located at the intersection of Morse Roads and State Route 310. The Beeson family operated the general store at Ash from 1895 to 1937. Pictured are daughter Jenny, mother Cora, and sons Richard and Roy Beeson. The building on the right was the post office and originally stood across Morse Road from this store. The entire building was razed in the early 21st century. (Courtesy of West Licking Historical Society.)

PURCELL BELLING. Belling ceremonies, called charivari, were popular during and after the Great Depression. Funds for weddings were scarce, and the bellings served as a way to celebrate the union. This belling of the Purcells in 1960 shows Yvonne Purcell in a wheelbarrow being wheeled down Main Street in Pataskala. The newlyweds were expected to furnish candy and cigars to the revelers. (Courtesy of West Licking Historical Society.)

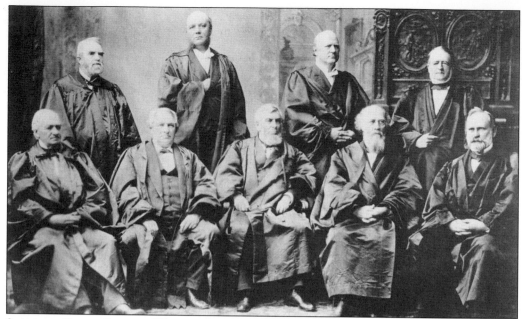

SUPREME COURT JUSTICE WILLIAM BURNHAM WOODS, 1882. The Newark native son served on the highest court in the land, the U.S. Supreme Court. William Burnham Woods is the distinguished gentleman shown on the far left in the back row. Woods was admitted to the bar in 1847 and began his practice in Newark. He was later confirmed by the senate as a U.S. circuit judge and nominated by President Hayes for the U.S. Supreme Court.

WAYNE AND JERRY NEWTON. Known as the Newton Rascals, 9-year-old Wayne and 11-year-old Jerry began their careers at Hillbilly Park, an outdoor staged music park. Wayne is an established fixture in his adopted hometown of Las Vegas, where he became the biggest box office draw, highest-salaried entertainer, and symbol of the city's particular style of old-fashioned glitzy entertainment. He returns often to see friends.

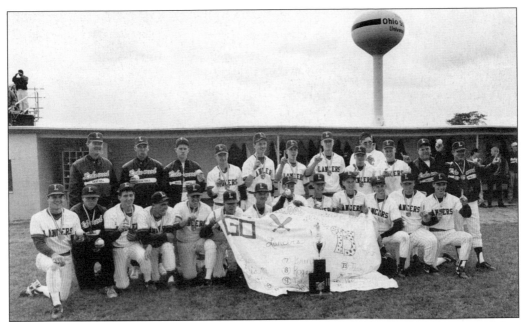

LAKEWOOD HIGH SCHOOL BASEBALL. The Lakewood Lancers baseball team won its first state championship in 1993 with the win 3-2 over Akron Hoban School. Coach Don Thorp's Lancers did all the little things that added up to one big Division II High School Boys Baseball State Championship. The team finished with a 28-4 record for the year. (Courtesy of Chance Brockway Jr.)

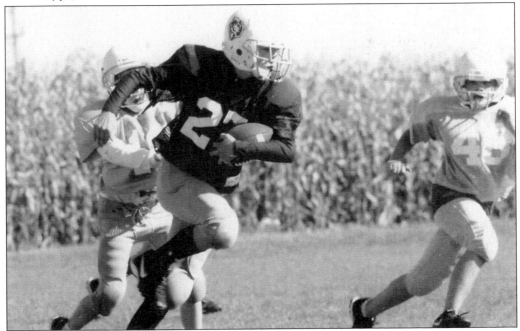

YOUTH SPORTS. The people of Licking County take sports very seriously as an entertainment venue, and the players begin early in their lives. On a beautiful autumn day with the tall corn as a background, Mark Porter runs the football for a touchdown with Trent Ghiloni and Dallas Martin in close pursuit. (Courtesy of Denise Henry.)

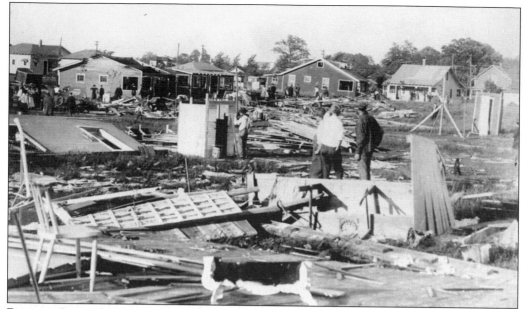

BUCKEYE LAKE TORNADO, 1922. At 4:55 p.m. on Sunday, June 11, 1922, a tornado swept over the park, bringing death and destruction. In its path, the storm left three Columbus people dead, at least 12 persons injured, and at least 50 cottages either totally or partially destroyed. Two weeks prior, a fire had destroyed seven concessions of the penny arcade, the lumber plant, the skating rink, and a part of the buildings of the amusement concessions.

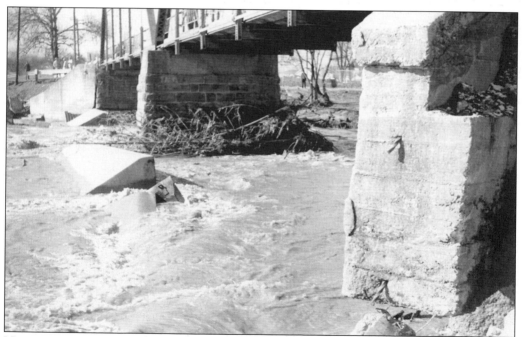

NEWARK FLOOD. In January 1959, destructive floodwaters covered most of Newark, resulting in the worst flood in the county's history at that time. Some businesses recorded water as high as six feet in their buildings. The power of the raging water can be seen where it created extensive damage to the town, including the waterworks dam. (Courtesy of Tim Bubb.)

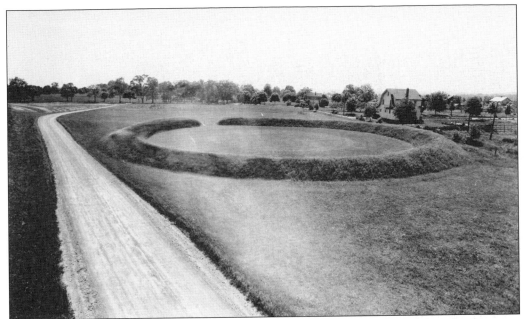

EARTHWORKS. Perhaps Licking County's most valuable and cherished treasures are the extensive earthen mounds built by the Hopewell people. These sacred structures can be found all around the county, and some can be seen as huge, geometrically formed enclosures in the shapes of tremendous circles, squares, and octagons. Today these ancient symbols are being eradicated by time or overrun by civilization. (Courtesy of Tim Bubb.)

LONGABERGER BASKET. One of the most distinctive buildings is the seven-story basket design that serves as the Longaberger Company headquarters. Measuring 160 times larger than the actual company's medium market basket, the building has been featured on television and in many noted architectural magazines. It features two gold-leaf plated name-tags each weighing 725 pounds and two heated handles designed to prevent ice from forming.